# Paintings in Progress

Bernard Dunstan

# Paintings in Progress

Pitman Publishing, London
Watson-Guptill Publications, New York

First published 1976 in Great Britain by Pitman Publishing Ltd,
39 Parker Street, Kingsway, London WC2B 5PB

Published simultaneously in the United States by Watson-Guptill
Publications, a division of Billboard Publications, Inc., One Astor Plaza,
New York, N.Y. 10036.

Library of Congress Catalogue in Publication Data
Dunstan, Bernard, 1920–
Painting in Progress
1. Painting—Technique. I. Title.
ND1500.D86   751.4'5   75-44084

ISBN 0-8230-3874-2

U.K. ISBN 0 273 00899 4

Copyright © Bernard Dunstan 1976

First printing 1976

Text set in 12/13 pt Monotype Bembo, printed by photolithography,
and bound in Great Britain at The Pitman Press, Bath

G73:16

# Contents

# Colour plates

# 1 Introduction

This book grew out of a series of articles written for *The Artist*, in which I intended to show some of the ways in which pictures can develop from their first beginnings. My original idea was simply to trace the progress of a number of paintings, from the first sketch through the vicissitudes, the alterations, second thoughts, even the bad patches, which many pictures go through. Most of the books written for amateur painters which try to follow a picture through several stages strike me as unrealistically cut and dried; nothing ever seems to go wrong. The painting starts with the subject drawn out on the canvas, then come the first areas of tone and colour, and finally the whole thing is brought together with the final touches.

Sometimes, indeed, the whole process is so well defined that the intermediate stages look almost as if they had been done afterwards. It is all a little too good to be true. Yet obviously some pictures do develop along such smooth craftsmanlike lines as these. But how many others go in fits and starts, backwards as well as forwards! They go through periods of crisis or inanition, are repainted, scraped down, even have bits cut off, before they can be called finished—and sometimes the wretched things have to be scrapped altogether.

When technical methods were part of a generally accepted tradition of craft, it would have been perfectly possible to follow the different stages of making a picture with clarity and logic. Thus, a portrait of the 18th century or a Florentine altar-piece would have gone through what Degas used to call 'a series of operations' which could be accurately predicted and, of course, taught—just as an apprentice is nowadays taught to gild a frame. Even so, as technical methods became more direct, certain artists were able to allow for the second thought; Rubens, for instance, sometimes added areas of canvas to enlarge his designs, and Reynolds painted over a whole figure in at least one of his finest portraits.

Since the 19th century we have had a very different approach

to the development of a picture, at least if we are interested in figurative painting 'after nature'. The painters nowadays who use defined technical methods which can be accurately predicted stage by stage tend to be, curiously enough, the abstract artists, and those who do not use nature direct but work through the medium of photography, such as the pop artist and the commercial illustrator.

So a really accurate record of exactly what happens to a painting in its progress from the first mark on the canvas to completion would be a fascinating thing to undertake. Unfortunately, as far as I am concerned, it is still merely a project. It proved almost impossible to organize. I would have needed a skilled professional photographer on call, ready to come and record a particular stage, which might have been reached twenty minutes or three months after the previous stage. The only possible way to do it was by taking my own photographs. This, I am afraid, is an unsatisfactory compromise, as anyone who has tried to photograph pictures can confirm!

However, I discovered while writing the original articles that there was another aspect of the matter which I had not considered before. This consisted not so much of the development of a single picture as the development of a theme through a series of pictures. I became aware that I was dealing with a fairly limited number of subjects, all of which seemed inexhaustible. One picture often led directly on to another, and yet another, dealing with the same or a similar theme, and I began to see that this was, after all, only another facet of the same search which, when it goes on in a single picture, results in changes, alterations and second thoughts—only here the second thought gets on to a new canvas instead.

On the whole it is when the pictures are on a small scale that they develop straightforwardly, and when they are larger that they alter and change during the process of painting. So most of the 'series' of pictures I deal with are individually on a small scale—though not all. Whenever possible, I have included the actual working drawings that were used during the painting.

I can only deal with the kind of painting I know about. This is traditional in the sense that it remains strongly attached to the subject, and to our direct visual perception of that subject. It has little to do with the attitude which uses the subject—or 'nature'— merely as a source of material for abstract or semi-abstract design. All the pictures I discuss are the result of an involvement with the subject for its own sake, and not merely with picture-making. If that sounds old-fashioned I can only reply that old-fashioned does not necessarily mean obsolete; and that sometimes the oldest ideas are the most living and fruitful.

For my part, I have never been able to dismiss subject matter or to feel that it was in some way less important than what was 'made out of it'. I would not paint at all unless I felt strongly about the things I paint; the people and the places that I feel a need to describe, commemorate, and fix into some form. It

follows, then, that I would never want or be able to depart more than a certain distance from the appearance of my motif. It is difficult to say exactly how far I feel bound to retain its character, but I know when I have gone too far away from it.

It is quite mistaken, in my opinion, to think that a comparatively realistic approach to painting necessarily means a straightforward, more orthodox, less 'adventurous' way of painting. Indeed I would say that it is often exactly the opposite. Figurative painting can give more scope for invention and improvisation, more possibility of bringing in different levels of meaning; it can be more of a tight-rope walk, with more risks to be taken, than any other form of painting—quite apart from the fact that abstract painting can only deal with emotional states in the most generalized way, whereas figurative art can call up exact feelings and specific moods.

An artist dealing with a subject he feels strongly about, and who is continually stimulated by direct visual contact with it, is much more likely to feel the need to keep modifying his image and having fresh shots at it. The 'likeness' that is surely one of the strongest motives for painting at all has to be balanced in all sorts of subtle ways against the purely formal aspects of making a picture—formal aspects which are by no means merely 'abstract', but which have the mysterious power of intensifying the feeling by concentrating and connecting the forms. Memory comes into the mixture, as well as observation; memory of other experiences connected with or suggested by the immediate visual facts. The artist may also be attempting, probably unconsciously, a sort of summing-up of several separate experiences. All this can, at any moment, be brought back to immediate and particular reality by the stimulus of something he sees. Like the scientist, the figurative painter must always be prepared to be surprised by facts, and to alter his preconceived ideas in relation to them.

The process of painting from nature, or from a drawing done from nature (it is not quite the same thing, admittedly), is thus a complex affair, not at all the simple copying that it is sometimes supposed to be, and I have only been able to hint at some of the interwoven strands that make it up. Its comparatively recent origin can be placed in the first half of the 19th century, with the exception of, perhaps, Rembrandt and Goya. Some people would date it more definitely from Cézanne.

Let me try to describe this essentially modern—though by no means universal, or, indeed, particularly common—way of working from nature. It is dependent on a technical method which will allow rapid alteration without needing to be built up predictably step by step. The use of modern oil colours 'alla prima' (meaning the use of direct and opaque touches) and the development of tube colours designed for such use, goes hand in hand with the interest in particular visual phenomena for their own sake, which is our legacy from the Romantic period.

The modern figurative painter is more likely than any artist of the past to feel that everything he puts down on his canvas has

the power to alter the whole painting in subtle and unforeseen ways. He cannot be quite sure in advance what its effect will be. A shape or a colour can be modified or re-drawn over and over again, and each time it will have a slightly different effect on its surroundings.

The idea of a painting as an improvisatory process, to a greater or a lesser extent, is an exciting one. On taking out a new canvas or panel one can never know exactly what is going to happen. This in itself helps compensate for the corresponding drawbacks of having no reliable technical method to fall back on.

The improvisatory process can be seen in the works of such different artists as Cézanne, Bonnard and Picasso. It takes different forms: in Cézanne, the continuous searching for the contour, often taking the form of innumerable delicate broken outlines placed one over another; in Bonnard, the modifying of colour areas with exploratory dabs and smudges of other, often quite unexpected hues; with Picasso, the most violent and radical reorganization of the whole image on the canvas.

As I pointed out earlier, although some of the pictures I deal with are improvisatory in their development, others are perfectly straightforward, while others again are part of a continuing series, showing one facet at a time of a particular visual situation that can develop an almost obsessional quality.

I hope these glimpses into a painter's workshop will be of some interest, and will demonstrate a few of the wide variety of ways in which pictorial ideas can grow.

Unless otherwise stated, all the paintings reproduced in the book are in oil on panel, and the drawings are in pencil. Hardly any of the drawings in this book were done with print reproduction in mind: the majority are from sketch-books or purely studies for the paintings. The greatest efforts have been made to reproduce them accurately though in some cases this has not been easy.

Measurements are in inches. Height precedes width.

Where it has not been possible to trace the size of a painting reproduced, I have given an approximate size.

# 2 Materials

Most books on painting contain an obligatory chapter on the artist's materials, but the information given is so often merely duplicated that I would prefer to make this a purely personal view.

Every painter must develop his own way of using the materials of his craft, and there is no particular value in finding out how another painter works from the technical point of view, except that anything to do with such a fascinating craft must inevitably be of some interest to those who are lucky enough to practise it. Apart from this it might sometimes be useful to find out that other artists have had to put up with, for instance, cramped working conditions, and that these things are not necessarily handicaps. Vuillard's painting, showing his friend Bonnard at work in an ordinary hotel room, is something which has had a lasting effect on me in this way. I think that at some time I also saw some photographs of him, as an old man, in a small hotel room. In both cases, his canvas was simply pinned up without any stretcher directly on to the wall, which was covered with a typical French wallpaper. His open paintbox stood on a table near him. In the Vuillard painting he is standing looking at his canvas, about to step forward and put a touch on it, and in his turn he is watched by a small dog. The whole scene is moving in its simplicity and unpretentiousness. There is no studio easel, no North skylight, nothing to impress; only the simplest possible tools, a room, his canvas and probably a few scraps of paper with working drawings scribbled on them. These pictures of Bonnard at work helped me to see that if you have powerful and exact sensations there is no need for complication; the simplest milieu will do.

So any room, I am sure, will do to paint in. Another great artist, Stanley Spencer, would quite happily work in the bathroom if there was no other space, or roll up a huge canvas in a small room and work on only part of it at a time.

All this helps to console me when I look round my own painting room, which contains so much clutter that I reckon in a

MATERIALS

floor area of about 18 × 11 feet there is not much more than 12 × 7 feet clear to move about in. So it is difficult to step back far enough from a canvas larger than, say, 30 × 25 in. I get over this to some extent by having a large mirror on one wall, so that by simply turning round I can see my picture from a greater distance and also, of course, reversed. This latter point is very helpful in giving a new view of a picture, which ruthlessly shows up any failings of construction or drawing. I was lucky to be able to acquire this mirror, which measures about 8 × 5 feet, from a local shop which was being re-fitted.

As you can see from the illustration on p. 48 and the chapter on bathrooms, I often work very close to the model. This is from choice as much as necessity; for one thing I am short-sighted, and have been working in small rooms for such a long time now that if I were put into a big studio I would probably settle down in one small corner of it. I would certainly never feel happy working in an art school life room, with its inevitable distance from the model. As well as short-sightedness, there is another aspect of this question of one's natural working distance, which is equally important to me. I need a certain closeness of human contact when I am painting someone. If you talk to a person it is not really comfortable to be more than a few feet away; and to me painting, or even more drawing, is very similar—if I have to be far away from my model I feel a lessening of the rapport.

This can, of course, make it difficult to draw a whole figure. I remember that when I was a student I was told that it would be necessary to stand 18 feet away from a standing model in order to take in the whole figure without any distortion. Personally I would prefer to run the risk of distortion. On the other hand, though, when I am working outside the studio—drawing musicians, for instance—I have to manage at a greater distance; so it must be largely a matter of habit. I only bring it up here to show that there is no need to feel too restricted by small working spaces.

Besides my big mirror I have one other improvement in my studio, which is essentially just an ordinary room in the house. It originally had a French window looking on to the garden. I took this out, together with quite a lot of the wall around it, to make a big studio window about 6 feet square. I retained one door of the French window so that I could still get in and out of the garden. At the top of this new window I have installed a simple lighting fixture so that the artificial light comes from roughly the same angle as the daylight.

This artificial light source consists of a 'daylight' fluorescent tube, plus two ordinary 150 watt bulbs. They are screwed to a board which is suspended from the ceiling. It is well within the capacity of the average person to wire up something of this kind. The light it gives is remarkably similar in colour value to daylight. Quite often in the winter I start painting by daylight and later switch on the lights without noticing any difference. Anyone who works in an English winter has to come to terms with electric light, or else do very little work, so it is most important to have a

**Figure I.** A studio lighting fixture which is easily rigged up.

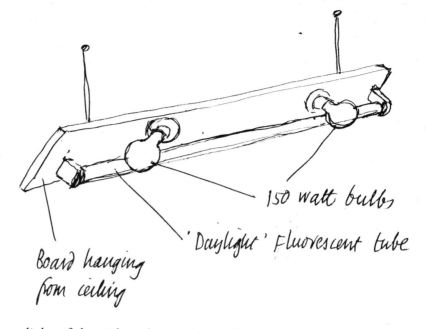

150 watt bulbs

'Daylight' Fluorescent tube

Board hanging from ceiling

light of the right colour value. Otherwise a painting which has been worked on by artificial light will look jaundiced, or worse, when seen the next morning in daylight.

My main extravagance is a very large and heavy old studio easel. This I find absolutely essential, in spite of the fact that I hardly ever do a painting large enough to extend it to its full stretch. The wide shelf at the bottom gives me room to prop up all the sketchbooks and drawings I need to work from, and the size and weight of the easel means that it always stands as steady as a rock.

As for actual materials, I believe firmly in a certain simplicity, even limitation. I only use standard oil colours, and for years have used the same medium—one-third linseed oil and two-thirds genuine turps. I have never been in the least tempted to use

**Figure 2.** The painting table.

acrylic colour, though I have sometimes worked in distemper, by which I mean the traditional glue-painting in which the powder pigments are mixed only with warm size.

When it comes to the surfaces I paint on, I must admit to being rather fussy. For small pictures I invariably use panels, and spend a good deal of time preparing my own. I have never come across any commercially prepared ones that were any good, and preparing panels is pleasant enough work in any case, rather like cooking.

I normally use hardboard, which is both rigid, stable and easy to cut—an ideal material. However, I like to cover it on the smooth side with linen or cotton before priming. Old sheets are ideal for this purpose. I always use a genuine rabbit-skin glue for preparing panels. This comes in the form of tough brown sheets which have to be broken up, soaked, and finally dissolved in hot water to form a liquid size. The panels are sized with this, and while still wet the cotton is smoothed over the surface and folded over the back. I give the panel another coat of size when it is dry, and then brush on two coats of white primer.

You never quite know what is in a commercial primer, so I use what is known as an 'egg-and-oil' recipe. It is a home-made emulsion—the old-fashioned sort which has nothing in common with what is now called emulsion paint. You can buy various acrylic primers for preparing panels and canvases, but they have quite a different 'feel', and I never use them. My recipe sounds very complicated; it is no worse, though, than making a white sauce. It is, in fact, a bit like cooking, for you start off by taking a whole egg. Mix it with water and oil as shown in the diagram

*Emulsion for primer*

1 egg

+ twice as much water

+ same amount linseed oil

**Figure 3.** Egg emulsion primer.

PAINTINGS IN PROGRESS

here. You can most easily measure the amounts by using the half egg-shell. Then you shake the whole lot vigorously in a bottle until an emulsion is formed. This means that the oily particles are broken down until they are so small that they remain suspended in the water. Some of this emulsion is then mixed into a pile of titanium white powder with a palette knife, until it is about the consistency of cream cheese. This is thinned with some of the same liquid size that was used for sizing the panels—you'll have to warm it up again, of course, and don't forget that size must never be allowed to boil.

As this priming is rather absorbent, I like to put another coat of size over it when it is dry. This primer can be used equally well for canvases, as it has a certain flexibility.

Sometimes I use a gesso ground to paint on. This is made simply by stirring warm size into powdered chalk ($CaCO_3$) until the result is a creamy liquid. Again, this priming is very absorbent, and needs sizing on the top. Sometimes I seal it with a coat of oil primer or undercoat.

I have a theory that the smaller the picture is the more vital it is to have a surface which accepts the paint in the most attractive way possible. I always tone the white ground with a thin transparent coat of colour, rubbed on with turps substitute and a rag, which is then left to dry hard. This means that one can get going on the painting much more quickly, as there are no areas of blank white to be covered up. I use different colours—buff, ochre, grey, blue or violet grey—to work on, and always try to have a pile of ready prepared canvases and panels in a corner of the room, of different sizes and colours, to choose from.

Most chapters on materials have a photograph of a beautiful clean range of brushes, straight from the manufacturer. As, in my experience, no brush that one actually uses ever looks like that for long, I am including instead a photograph of the brushes I am actually using at the time of writing this chapter.

There is not much to say about brushes, except that as you can see, most of the ones I use are round and have fairly long bristles. This, like everything else, is a matter of taste; but I would

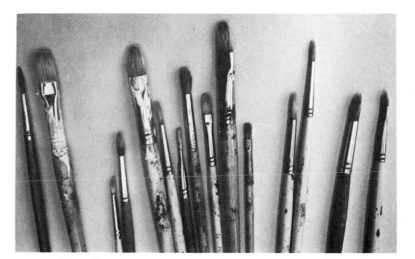

**Figure 4.** A handful of brushes in use at the time of writing this chapter.

MATERIALS

suggest that it is easier to work with a certain variety and sensitivity of touch if one uses a long-haired brush. The shorter and squarer the bristles are, the more one is restricted to a limited variety of marks. Brushes like the ones illustrated can make with equal ease a soft scrubbing movement or a relatively precise, linear touch.

Although fairly worn and scruffy, they are all in fact kept scrupulously clean, being washed out with soap and water every time they are used.

There is another reason for showing you used brushes rather than brand-new ones. Good brushes are improved, up to a point, by being used; their useful life could be represented by a graph which rises to the most useful point and then descends down to the time they are thrown away or pensioned off for menial tasks. Most painters collect vast numbers of old brushes which have lost their shape but still have a bit of life in them.

When you go abroad to paint it is particularly important that your materials should be simple, familiar, and well organized. I take plenty of panels—it is much better to have to bring some home than to run out—and aim at being quite self-sufficient in colours and other things, as there are not likely to be shops around just when needed. When travelling one finds out very quickly the advantages of working on a small scale. I can take twenty or so panels, of about the size that will fit the lid of my sketch box, in a case together with the rest of my possessions. My box takes a few more, together with all the colours I am likely to need. A few spare tubes can go in the case, with a couple of bottles (tight screw tops are essential!) containing medium and turps, along with sketchbooks, and camera.

After bitter experience of sketch boxes which open unexpectedly and deposit all one's tubes and brushes on the ground, I take a certain pleasure in owning a really fool-proof one at last. This came down to me from an elderly painter, and is, I should imagine, at least 50 years old. As you can see, it has an unusual design of catch, which locks very securely when the brass angles are pushed in and their nuts tightened up.

The travelling painters' outfit is completed by a camp stool. As it has to be big enough for comfort and light to carry, the aluminium variety is essential. My wife and I both paint, so I usually make up a bundle of two paintboxes and two camp stools securely strapped together.

An alternative way of working, if you don't mind producing only very small oil sketches, is to use a pochade box, or thumb box. This is really a miniature paintbox, and is so small that it can be held on the thumb like a palette. It holds a small panel, or pochade. The box I have measures 10 × 8 in. and is thin enough to slip into an ordinary brief case or carrier bag; there are even smaller examples, which could go into a poacher's pocket, if you had a jacket with such a refinement.

Of course, a box as small as this will not hold tubes of paint.

PAINTINGS IN PROGRESS

**Figure 5.** A paint box which cannot fall open at inopportune moments.

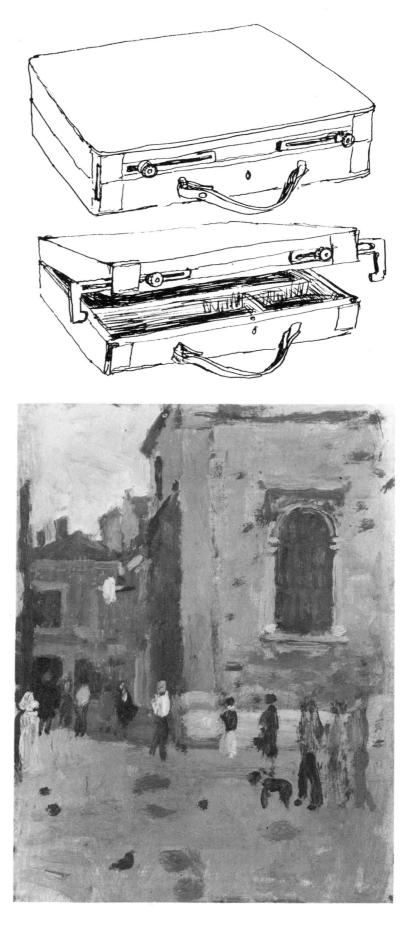

**Figure 6.** Pochade study: *The Carmini, Venice* 9 × 7 in.

The palette, which forms the bottom of the box, has to be set before one leaves home, and strictly speaking one can only expect to paint one pochade before returning to base, though I usually carry one or two spares. There is room for a couple of cut-down brushes and a small dipper.

It is possible to stand unobtrusively in a corner of a street with the pochade box on one's thumb, painting a tiny complete picture. Figure 6 was done like this in Venice, a city where onlookers will appear as if by magic if you sit down on a camp stool to draw or paint. Many painters have used the pochade box not so much as a means of painting finished panels but for making hasty colour notes, perhaps only putting down a few touches of colour to act as information for a more complete picture done in the studio.

I should mention one other item: the camera. Especially when travelling, I carry a camera and take photographs of many of the subjects that I draw. A photograph can be of great use afterwards if it is used purely as documentation, to give additional information if there is something in the drawing which is not clear, or for which there has not been enough time. Many painters are very chary about admitting to the use of photographs, and I can sympathize with them, for the camera has to be used with great reticence and never be relied on too much.

One can usually tell when a painter has relied too heavily on the camera by an indescribable (but immediately recognizable) thinness, almost a deadness, about the image. I am particularly aware of this nowadays in the work of students who have been allowed—sometimes even encouraged—to work from photographs.

Still, if one is able to use the camera for very limited purposes, and never to rely on it, there is no doubt that it can make a very useful addition to one's sketchbook. I always take a small camera which can be slipped into the pocket. It is important that it should

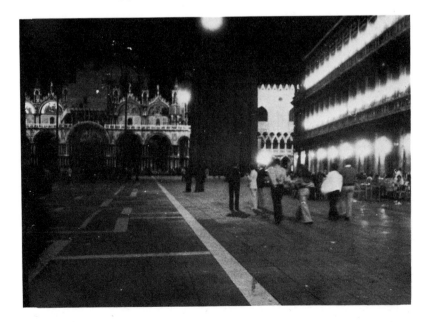

**Figure 7.** Photograph of the Piazza at night.

PAINTINGS IN PROGRESS

have a reasonably good lens and slow shutter speeds as well as fast ones, because I often need to take photographs in very poor light. Figure 7 is an example; with a fast film, quite useful records can be made at dusk or even at night, and an exposure of 1/10 or even 1/5 second can be made with the camera held in the hand. A little blurring doesn't matter much; a bad photograph is often more use to the painter than a nice sharp one would be. It leaves more to the imagination. It goes without saying that all photographs taken as records should be taken in 'available light', as the photographers call it, as a flash would totally alter the lighting. Similarly, colour photographs are to be avoided; they are too complete in themselves, in a generally misleading way.

I have said nothing about bringing your wet pictures home. In my experience this is not the problem it may seem to be. We generally use a hired car when abroad, and the wet panels lie about on the back seat drying out. A fairly thinly painted panel, on a normal ground, should be dry enough to pack in a few days, as long as some care is taken. I put a sheet of newspaper between each panel, and make up a bundle of them to go into a case. The panels which have been done in the last couple of days, and are still sticky, can usually be fitted into the paintbox lids. If the worst comes to the worst, two wet panels could be tied together with string face to face, with the painted surfaces kept apart by laying matchsticks along their edges, but I have never found this necessary.

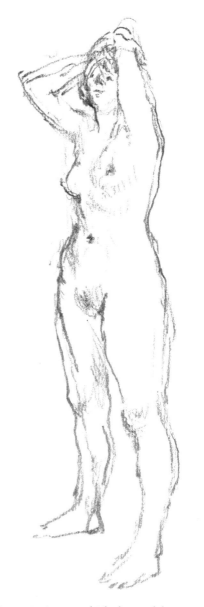

**Figure 8.** A pose which the model was able to keep for about ten minutes.

I have always found it difficult to stop when I have come across a theme that interests me. One picture leads to another, and so my output tends to be in groups or series. There might seem to be a danger of repeating oneself when working in this way, but I can't say that I ever worry about that. One picture, or six, or a dozen, cannot possibly be enough to say all that there is to be said about a particular subject. If it happens to be a figure composition, the turn of a head or the movement of an arm can alter the whole design and suggest a new one. This often happens in doing a life painting or a portrait when the model takes a rest. She stretches and relaxes; the muscles which were feeling the strain are rested, and others, their opposites, brought into play. In a sense the 'opposite' action is performed, and a contrasting pose results. This relaxation of tension, and setting up of an opposed movement, nearly always in my experience results in something beautiful and 'drawable'. As a small example of this I have done two drawings, the first one of the pose that the model was asked to hold, and the second of the completely unpremeditated pose that she relaxed into after holding the first position for about a quarter of an hour. Strictly speaking, of course, it is not a 'pose' at all—the word sounds like a self-conscious action—but there seems to be no other suitable word in the language.

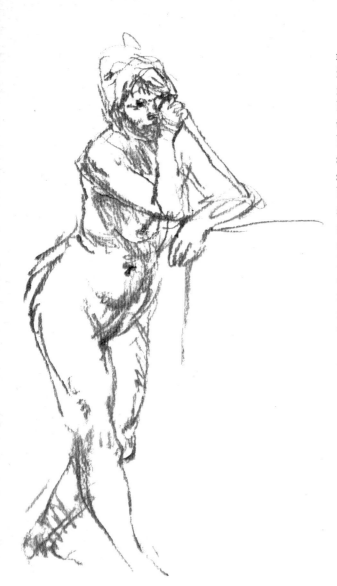

**Figure 9.** The model relaxed naturally into an equally expressive pose after the strain of holding the first pose.

When this sort of thing happens, I like to make a quick memorandum of the new idea, rather than let it go by. This means that it is necessary to keep alert all the time and not merely when the model is posing. The result can turn into a new picture, even the beginning of a new series of pictures. Of course, it is all too easy to over-concentrate on one's original idea, so that one is blinkered by it and any variation or diversion goes unnoticed. I have often seen how students in a life room will stop looking when they stop drawing at the model's rest times. They will even turn their backs on the model just as she relaxes into some eminently drawable pose. However, if one does keep one's eyes open the possibilities, even in a very simple everyday subject, are almost endless. For instance, a change in the direction or quality of the light can alter the whole feeling of a subject; a pink towel left over the back of a chair can entirely alter the colour harmony. It is almost too much of a temptation to paint picture after picture in which the same basic elements are played about with like variations on a theme in music.

In some sense the whole of many artists' production can be seen as one long series. Renoir, for example, never needed much more in the way of a subject than a plump model whose skin 'took the light'. His work could be described as one long series of variations on this theme.

However, what I am talking about here is something a little more specific than the continued absorption in one area of subject matter. I can best illustrate this point by taking two recent series of small pictures that I have done myself. The subject of one—to be dealt with in a subsequent chapter—is the Campo at Siena, and the other deals with a particular effect of light in a particular room.

Of all the rooms in which I have painted, I think that this bedroom of a Welsh cottage is the most attractive. It is not as if very much light enters it—in comparison with the traditional north-lit studio it is an absurd place in which to try and paint—but the quality of that light is ever-changing and extremely subtle. The windows, one at either side of the room, are very small and set low down in the thick stone walls. A subdued illumination filters through them, and not much of the light comes direct from the sky; it reflects from the field outside, sometimes green, sometimes snow-covered, or through trees. The walls are plain white, the doors simply made from planks, in cottage style. Facing the bedroom door is the bathroom with a small landing in between, so you can look through from the bedroom to the bathroom and vice versa. Both views make ideal settings for a figure engaged in the natural actions, always new, though they have been repeated thousands of times, of washing, dressing and undressing. Here are two small pictures showing how the same setting looks, seen from the two rooms. The model is in exactly the same place in both of them, Plates 1 and 2.

This room has brought home to me forcibly the fact that for my sort of painting there is no need at all for a conventional

studio. The colour is far more interesting than in any north-lit room, and changes throughout the day; a window recess against the wall may be warm against cool blue-grey in the morning, and faint violet against gold in the evening. Of course it would be a maddening room in which to try and paint a portrait all day; but I wouldn't dream of doing that in any case.

This simple setting seems to have the power to suggest a new set of ideas for pictures almost every time I come to it. I have developed a way of working in it which is adapted both to the dim and changing light and to the household routine, for my wife is my model here. I work largely from drawings and notes, at least as far as the figure is concerned. The more static parts of the painting, the setting itself, can be painted on the spot, and to my mind the picture does gain something in immediacy if at least some of it has been painted directly from nature. There is always a danger that the quality of the paint, when working from drawings, may become too deliberate, even stodgy. The comparative freshness and directness of the paint which has been put on 'from nature' helps to influence the quality of the rest of the picture. Of course, in this changing light it is necessary to be very careful only to paint at the correct time of the day.

Nearly all the studies for this particular series were made early in the morning, before breakfast. On a dull grey morning the

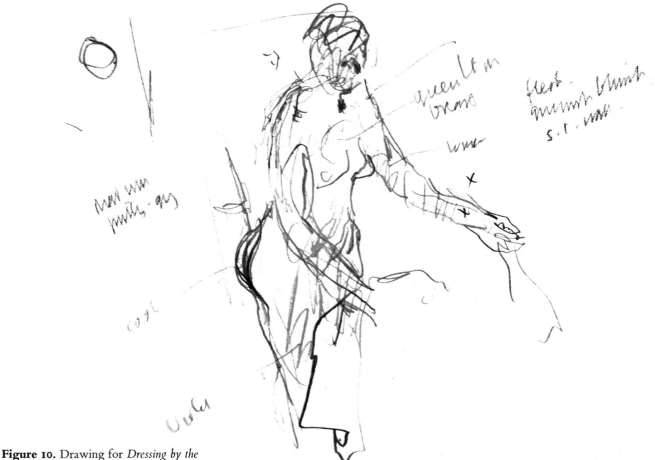

**Figure 10.** Drawing for *Dressing by the Doorway*.

MATERIALS

light filters in reluctantly and without warmth, and it is necessary to turn on the lights. I noticed that if the light is left on in the bathroom, which happens to have a rosy pinkish coloured shade, the contrast between this rosy light and the grey light from the window causes a nude figure to take on a strange, almost greenish colour. It is a question of the contrast between a warm and a cool light, and the subtle things that can happen to colour in relation to them—especially the colour of flesh, which is so suggestible and so open to influence from its surroundings.

As I made a rapid study for the first of these attempts I found myself writing, as colour notes to remind me later when I came to paint, such descriptions as 'greenish blue, same tone as wall' and 'putty-warm grey', for areas of light and shadow on the figure. It doesn't sound at all flattering, but the effect was, in fact, most beautiful; and it was heightened, to my mind, by what amounted to a reversal of what is usually typical of paintings of the nude. One is inclined to think of the nude, in Sickert's words, as 'a flash of warmth and life', contrasting with her surroundings, but here the figure was the cool, shadowy part of the picture in contrast to the warmth of the artificial light behind her.

Again, to some extent one is accustomed to accept the convention that things in the foreground are stronger and brighter in colour than those in the distance. Some art students, indeed, are so brainwashed by theory about colour that they are almost incapable of believing that a warm colour won't inevitably 'come forward', or a cool one recede. In a subject like this one, the sharp, glowing accents are all kept right back on the furthest plane of the picture. There is nothing very startling about this, admittedly—Bonnard, for example, was a master of this kind of reversal of the expected order—but here it did seem to me to add a further attraction.

The drawings I make for this sort of painting are usually quite small and covered with written notes. Sometimes these are no more than reminders, sometimes they are relatively complete, with almost every important area given its note of description. One or two comments on the notes that you will find just visible on the drawings reproduced may be of interest. I find it extremely helpful to note carefully when two areas of colour or tone are of the same or similar value. I put either an 'x' against each area, as you can see in the arm in Fig. 10, or write something like 'green st wall', where 'st' stands for 'same tone'. Indications of the temperature of the colour, such as 'cooler', 'warm', may be as useful as more specific notes as these distinctions, so important in developing the colour, can still hold good even if the whole picture is transposed into another key. For instance, if I decided to paint the picture in an almost monochromatic scale of greys, it would still be essential to make a distinction between warm and cool greys.

Another useful indication is to show where an edge is strongly silhouetted, or where it merges into another area. I sometimes show this in a shorthand way by using a blurred or dotted line,

PAINTINGS IN PROGRESS

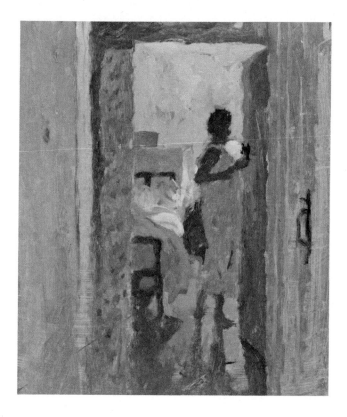

**Plate 1.** (Above) *Diana in the Doorway I* 11 × 9 in.

**Plate 2.** (Below) *Diana in the Doorway II* 11$\frac{1}{2}$ × 9$\frac{1}{2}$ in. The model is in exactly the same place as in Plate 1.

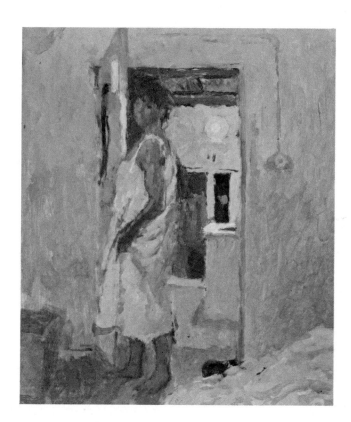

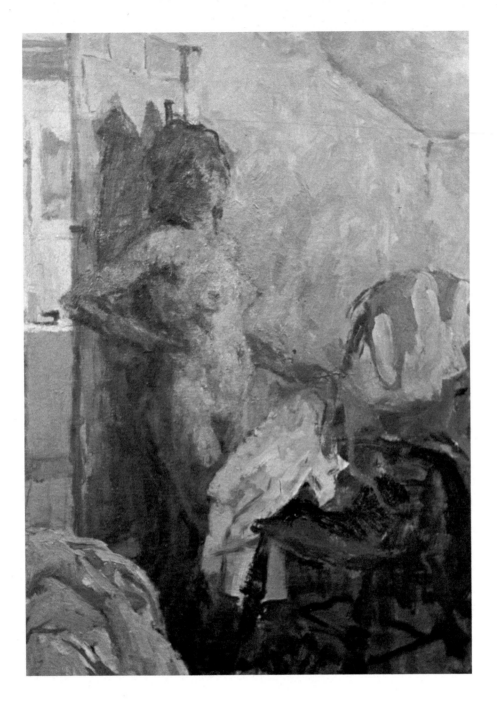

**Plate 3.** *Dressing by the Doorway: Stretching.* After repainting.

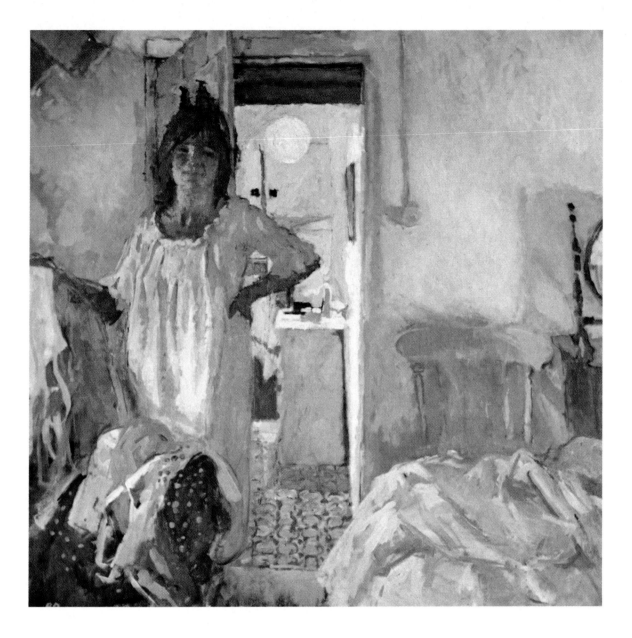

**Plate 4.** *Winter Morning*. Oil on canvas 42 × 42 in.

**Plate 5.** First stage of *Portrait of Lindsey*.

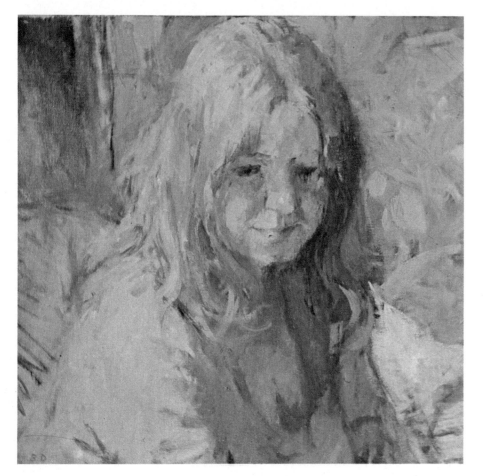

**Plate 6.** *Portrait of Lindsey*.

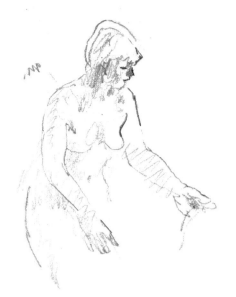

**Figure 11.** One of several drawings done for the painting *Dressing by the Doorway*. It does not pretend to be more than a statement of one or two facts which will prove useful in carrying out the painting. Other drawings will be concerned with noting other aspects. Here, apart from the general pose and action of the figure picking up clothes from a chair, the facts noted are largely to do with the way the light falls.

**Figure 12.** The painting is an amalgam of several drawings and many separate observations; but the original idea must be retained through them all. Variations from this theme are noted, but kept for other pictures. The idea here came firstly from seeing the nude figure lit by very dull daylight, in contrast to the bright, warm artificial light in the room through the doorway; and secondly from the pose of leaning forward to pick up clothes from a chair.

in contrast to a sharp or accented contour.

The drawing in this particular case is largely devoted to the figure, although the surroundings are also noted down in their position relative to her. This is a purely personal way of going about a drawing, which has evolved over the years. It has the advantage that I am able to use very fleeting poses, which no model could be expected to hold for more than a minute or two. The leaning forward pose in Fig. 11 is an example. Try doing it yourself! The drawing probably took just under a minute. I make no claims for it at all as a drawing; it is an *aide-memoire* and nothing else.

The picture was continued for several mornings in this way—a quick drawing early on, followed by an hour or so of quiet painting after breakfast, without the model but using both the drawings and the actual room in front of me.

After I had made the second drawing, she stretched her back to relax it after the strain of leaning forward. This naturally led to a new lot of drawings, and to a second painting (Figs. 13, 14 and 16). For this I took up a small picture of an interior which I had

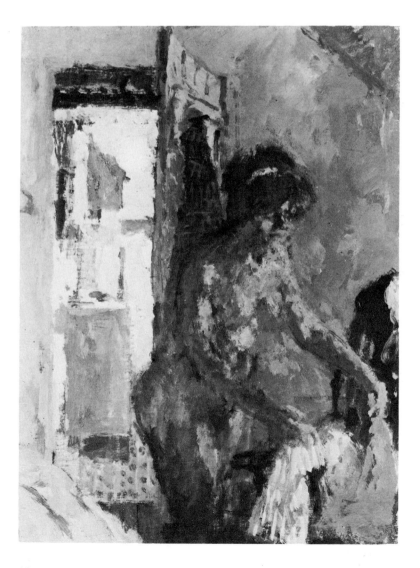

MATERIALS

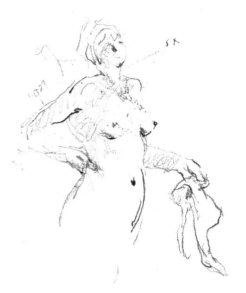

**Figure 13.** Drawing for *Dressing by the Doorway: Stretching.*

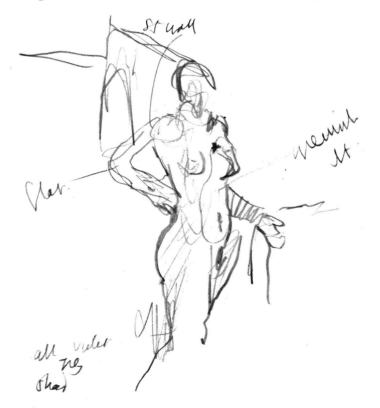

**Figure 14.** Drawing for *Dressing by the Doorway: Stretching.*

brought with me to the cottage to finish. It had a figure standing by the closed door. All I had to do was to open the door and then repaint the whole picture in reference to the new idea. The chord of colour remains similar to the first picture, but the composition is considerably changed, with the lit doorway pushed over to one side.

This shows how a shift in the placing of the figure in relation to the rectangle can completely alter the rhythms of the composition. The clothes on the chair now became far more important; the diagonal movement created by them, leading from the bedclothes in the left-hand corner up to the clothes hanging over the back of the chair, echo the strong diagonal of the arm. This is picked up at the top of the picture by the line in the ceiling. Meanwhile other diagonals are running in the opposite direction; the lines of the forearms and the sloping ceiling are echoed by the pile of bedclothes, and even by the dressing gown hanging behind the door. I have done a little diagram of the composition (Fig. 15) to show how these contradictory 'pulls' help the design to hold together.

I find that I never do a study like this composition sketch as a preliminary to the painting. I seldom grasp these rhythms straight away, they gradually emerge as the painting proceeds, but they are always there, in one form or another.

The picture, as shown in Fig. 16 was framed and exhibited, but all the time I knew there was something about it that didn't satisfy me. Compared to the studies, the action of the figure seemed lifeless—she wasn't really stretching, and there was something too cold about the colour. Even that brightly lit

PAINTINGS IN PROGRESS

**Figure 15.** Diagram showing some angles and connections in the preceding picture.

bathroom didn't look quite as inviting as it should have done. However, it was not until a year later that I decided to take up the picture again and do some repainting.

Taking up an old picture to make modifications is very difficult for some painters. They feel sometimes that once a statement has been made it would be better to start completely afresh rather than run the risk of losing what is already there. Sometimes, too, they feel that the surface of the dry paint is inimical to alterations, or that one change will mean repainting the entire surface of the picture. But I rather enjoy the feeling of bringing the image to life again, and experimenting with something that has become dead. You need, I think, to feel that any change is likely to be an improvement, and to be prepared to change the picture drastically; for it is necessarily an experimental process, and there can be no guarantee about what will happen.

To give the figure a little more tension, the suggestion of merely leaning slightly backwards had to be corrected. I decided the pose of the head had something to do with this. With the head thrown

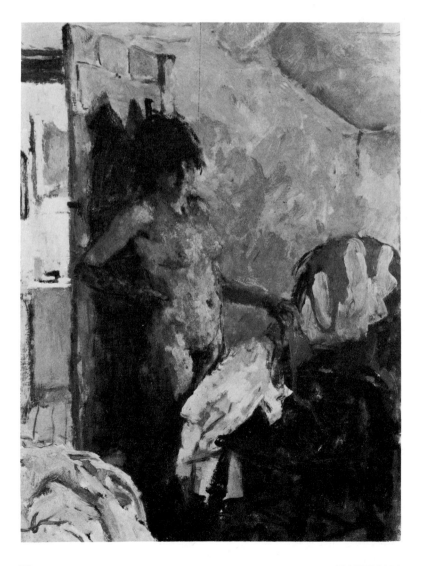

**Figure 16.** *Dressing by the Doorway: Stretching* before repainting.

MATERIALS

back more, as in the original drawing, the whole mood seemed to alter. After that it was largely a matter of small adjustments to the arm, the abdomen and the far leg. The feeling of warmth in the bathroom was a matter purely of colour. I put a glaze of a pinky-ochre colour over the rather cool, greyish pinks that were there already. A glaze is a transparent wash of oil colour thinned with medium. Like a watercolour wash, it merely alters the colour and tone of an area without covering it opaquely.

There was a third version, which came about in exactly the same way—a movement, a casual pose, seen and noted. The lighting was similar, but the composition, again, was slightly different. Having done these small pictures and explored the subject a little, I wondered whether it would be possible to do a large version. There were still things I wanted to explore, and I couldn't resist the temptation to attempt a summing-up. I have always found it practically impossible to paint a picture which is simply a large version of a small panel. For me the difference in scale demands a quite different approach. So I made no attempt merely to enlarge one of the small pictures. I used a different drawing and pose, and started the big canvas—actually less than four feet square, but that is quite large for me—away from the *motif*, when I was back in London a week or two later. It turned out to be quite a reasonable start, but after a little more work on it I had to admit to myself that I was not progressing at all well with the picture. Away from the original stimulus of the room and the light, and having to rely entirely on studies and memory, it proved very difficult to push the picture forward, and the canvas spent long periods with its face turned to the wall. There was only one thing to do—to take it back to the cottage next time we went there, and re-work it on the spot.

This I did, making one drastic and radical change. It had started as a nude like the small versions; I had, however, some drawings in which a rather charming Victorian-style nightdress figured. My wife tends to buy such minor extravagances on the pretext that they will come in useful for my pictures, and indeed they do get put down as tax expenses; so here was the chance for this one to earn its keep. Under the dull grey morning light, its crisp whiteness took on a curious luminosity and altered the relationship of the flesh to the warm light in the bathroom in a very attractive way (Plate 4).

Eventually I repainted every part of the canvas, and did so direct from the subject in front of me—something that I did not expect at all when I started the picture. This is, in fact, the first large picture I have done for a very long time in front of the *motif*, and I came up against one major difficulty. The original small pictures had all been done in the winter; now, at Easter, we were getting one sunny morning after another—very nice, of course, but absolutely ruinous to my carefully balanced scheme of lighting, for which grey mornings were essential. Fortunately, however, there were enough grey mornings to enable me to complete the picture on the spot.

# 3 A portrait

This was not a commissioned portrait, but one done entirely for my own pleasure. If it had been commissioned, a whole extra set of feelings and compulsions would have come into play, and the result would no doubt have turned out very differently. It would almost certainly have ended up as a better likeness; but equally surely it would have lost a good deal of whatever freshness and directness it now possesses.

I started off with no very definite idea of what I wanted to do, with few preconceived notions. I did, however, know roughly what size I wanted to paint—not too large, but big enough for the head to be around life size; and I had some idea of the time I wanted to spend on the painting—two or three afternoon sittings. I did not want to try to do a formal portrait, but one with a casual pose and setting. Finally, the panel I intended to paint on played its part in determining the character of the final result. Not only its size and shape, but the quality and texture of its surface seemed suitable for a freshly and rapidly painted study—it had been toned an attractive bluish-grey colour, and the priming had a slight richness and variety of texture; there was nothing in the least raw about its surface. A panel like this invites direct, fresh touches with a full brush.

These, then, are some of the factors, some positive, some negative, which play their part in determining what sort of a picture one is going to paint, even before the first sitting starts. Most important of all, perhaps, is the fact that I already knew the sitter—an ex-student—quite well, so that I had already seen her face in different lights and from different angles, and had formed, consciously or unconsciously, ideas about her appearance and how it could be painted. You notice that I say her appearance, rather than her personality or her character. Many people seem to believe that when painting a portrait the artist consciously strives to 'express' his sitter's personality, and this implies that by some inherent or developed talent he is able to sum up what this character consists of. In my experience this is seldom true. The

33

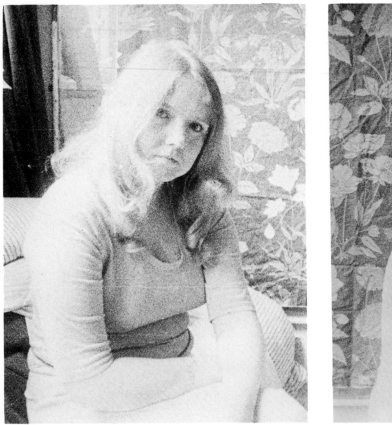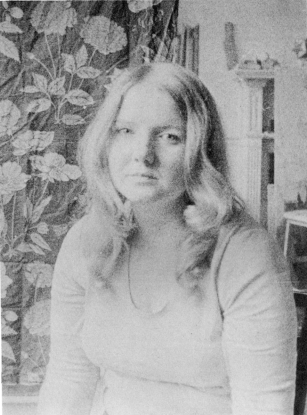

**Figures 17 and 18.** Photographs of the sitter.

painter looks at the *outside* of his model, at his or her appearance, and this gives him quite enough to get on with without worrying about less visible characteristics.

You will see from the photographs (Figs. 17 and 18) that Lindsey has a round, rather pale face framed by straight fair hair. The forms are unaccented, almost childish. The lighting of her face became my preoccupation during the first sitting, which was entirely given up to making drawings. I came to the conclusion during this session that I wanted to use a subtle lighting which would not give any strong contrast of modelling, or any intense shadow.

Lindsey made herself comfortable on the couch in front of the window. The light came from behind her. She was wearing a light-coloured dress, and the light reflected from the surfaces around her upwards into the shadowed face. I made a number of drawings based on this lighting; I altered the angle of her head and turned it this way and that, but never departed from the basic idea (Figs. 19–23).

When I am making drawings for a painting in this way, I often find that the rests are more important than the periods of actual drawing. Your model may be a little stiff or self-conscious at first, but as soon as you ask her to take a rest you are likely to find that she relaxes and takes up a natural and unconsidered attitude which may, if you are alive to the possibilities, lead you on to something much more worth painting than the pose you

PAINTINGS IN PROGRESS

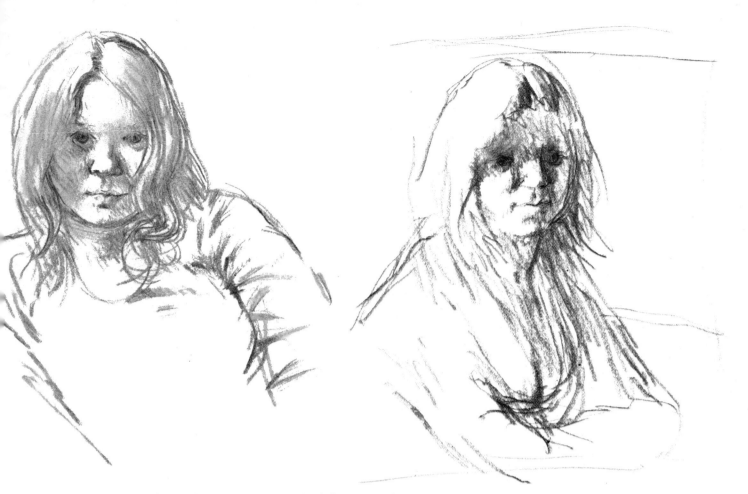

**Figure 19.** Drawing (charcoal.)

**Figure 20.** Drawing (charcoal.)

had been working on. This didn't, in fact, happen here, as Lindsey sat very naturally; but I did take the opportunity of making a few drawings during so-called rests, while she rested her back (Figs. 24 and 25).

The last of the drawings of the head led me directly into the painting, with the slight changes of angle that you will notice in Fig. 23. This enabled a little more light to fall on the cheek, and made the line of the shoulders more graceful. Once I have decided what I want to do I like to get going on the canvas without any more delay. First, however, it is necessary to check that your sitter's pose, besides being satisfactory from the point of view of the painting, is also reasonably comfortable. I never work from an uncomfortable model; to take only the most selfish view, it can be extremely distracting for the painter to have to keep asking 'Are you all right?'. Lindsey was leaning forwards with her elbows on her knees; this seemed quite easy, but all the same I let her have fairly frequent rests while I was painting—at least every half-hour.

The painting, then, was a logical development from the drawings, like the nude (page 31), and it began in much the same way: by beginning to place the head on the canvas in terms of a very simple drawing with the brush, using colour thinned with plenty of turps substitute. The purpose was no more than to establish its size and position. As soon as this was reasonably clear I began to

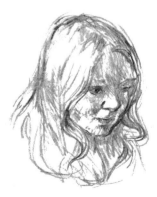

**Figure 21.** A preliminary drawing in charcoal for the portrait. The model was sitting on a couch, with the light coming from behind and to one side of her. Her round, rather pale face looked very charming in the rather subdued lighting, with most of her face in half-shadow and no very pronounced modelling.

A PORTRAIT

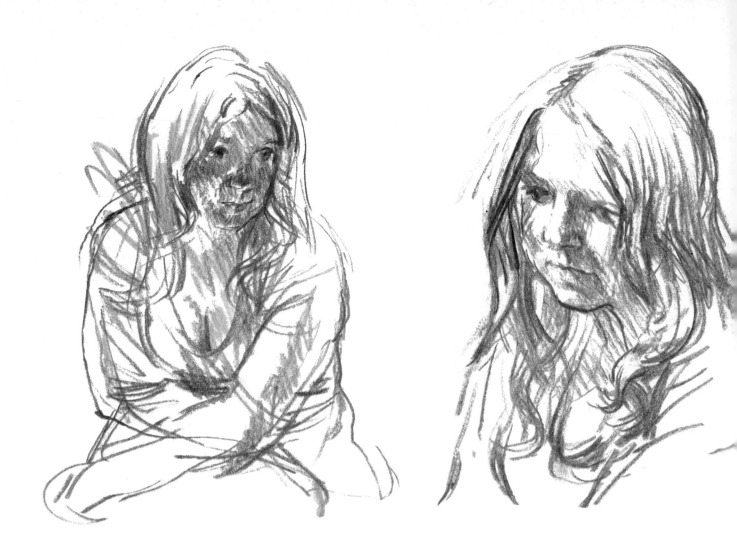

**Figure 22.** In this study there is no direct light at all on the face, but there is a certain amount reflected upwards from the light dress and arm. This reflected light always seems to give very tender modelling and colour. However, it is easy to exaggerate its effect. The tonal range is really very close, without strong lights or shadows. If the tone is 'forced' the result will look flashy. Similarly the colour is tender and subdued, with gradual changes from warm to cool.

**Figure 23.** Drawing (charcoal.)

mix a few adjacent areas of colour, such as the shadow side of the face and the darker part of the hair, and the patch of bluish background that comes next to them, and started to place these areas on the canvas to see what they looked like—considering them, for the time being, merely as flat patches of tone. Meanwhile the drawing, such as it was, had arrived at the edges of the canvas. In other words, not only was the head established in its position, but the surroundings, such as the cushion behind the model and the edge of the couch to her right, had been considered in relation to it.

I should have mentioned the background—though perhaps I should say here that I don't like to use the word 'background' too much. It sounds like something not very important, a mere backcloth, subordinate to the really interesting things that are going on in front. Actually, everything that happens behind and around a head is important, as much so as is the sky in a landscape. Anyway, there was a large mirror on the wall just behind where Lindsey was sitting, but I did not want the complication of a reflected image and so put a piece of patterned material over it. The piece I chose was blue with pink and white flowers, and it seemed to suit the general colour of the picture. In the course of painting however, I began to wish for something still lighter.

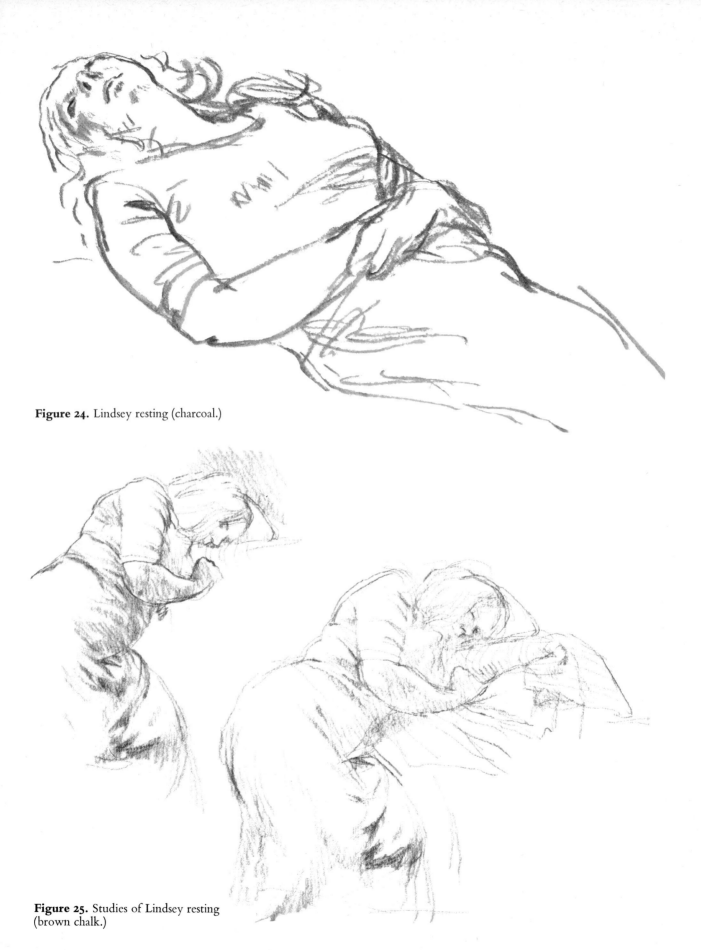

**Figure 24.** Lindsey resting (charcoal.)

**Figure 25.** Studies of Lindsey resting
(brown chalk.)

A PORTRAIT

The solution was easy to find. I simply reversed the cloth, so that the pattern showed through more faintly.

After the first two sessions the portrait reached the stage shown in Plate 5. In accordance with my intention of keeping the whole painting as light and fresh as possible, the touches are left separate and put on over the whole area of the picture. Thus the head is not taken much further than any other part—the background and the hair, for instance. The drawing is still much in evidence everywhere, and is continually being added to as patches of colour are put on. The tonality of the whole thing is by this time fairly completely established. In other words, the values of the darker and the lighter parts have been decided. Passages which have not yet been stated at all are still the colour of the original bluish-grey ground, which harmonizes with the touches put on to it and does not stand out as much as a bare white ground would.

This is an example of a picture in which the important decisions, in spite of an appearance of indecision, were actually taken before the brush touched the canvas. The building up of the image then followed fairly straightforwardly. There were no bad hold-ups, and after two sessions of painting I felt that I had gone as far as I wanted with the head (Plate 6).

You will see that the final session has been used mainly to 'close the gaps' between the touches seen in the first stage of the portrait (Plate 5). In other words, the transitions between one tone and another have been made more subtle. This seemed to me a more pressing task than developing the drawing of the features. These are taken far enough to establish a fair likeness, without over-modelling or laborious drawing (I would add that I always like to get some degree of likeness, whatever the purpose of the painting). Some of the complex swirls of the hair were, in fact, given more attention than the eyes.

There was only one major alteration. This took place after the picture was finished, and consisted of cutting off a strip down the right-hand edge of the panel, and a much smaller one off the left, making the picture squarer. This can be a very risky thing to do. Sometimes I have intended to cut off a piece from the side of a panel, and left it blank all through the course of a painting, only to find that when it was cut off the picture looked a little unhappy, as if it lacked something. I have come to the conclusion that one subconsciously relates whatever one is doing to that area of blank canvas. When it eventually goes, you are, in fact, removing a working part of the picture, not a mere blank. Much better to cut it off straight away, or else leave it alone. In this case the whole surface was painted up to the edges. I had a frame which I moved around until I decided it was in the right place. Even so, after cutting the panel I had to do a certain amount of adjustment and repainting of some of the areas which came up to the edges.

Looking at these photographs again, I can see rather clearly the disadvantages of being able to compare different stages. So often the earlier ones look better!

I hope there is a reasonable explanation for this. I think it is a

misleading effect of the camera. Any picture which has a linear character, with vigorous drawing showing plainly, is going to look better in reproduction than a comparatively subtle tonal statement, in which the lines of drawing have been reduced or covered up by patches of carefully judged colour. My own pictures, I might add, seem to suffer particularly from this tendency to go fuzzy or muddy when they are reproduced—or so it seems to me!

Thus the first stage of the painting (Plate 5) looks to me livelier and more vigorous than the finished portrait. I know myself that this is not really so; the camera has softened and blurred the drawing in some places, and has probably also brought the tonal changes a little more together.

Another thing that reproductions do not show, of course, is the quality of the paint surface. I think that if you could compare the originals of Plate 5 with Plate 6 you would see that the vigorous brushwork of the first stage was done with comparatively little paint, leaving a lot of the panel unpainted. The finished version, however, has a consistent and fairly 'well-nourished' surface.

None the less, it is quite a salutary experience to look at photographs of unfinished work with this in mind; it makes me think that I would do well, perhaps, to leave a little more of the frank linear touches of the earlier stages.

# 4 Direct painting from the nude

The paintings illustrating this chapter are all nudes. They have another common denominator in that they were all painted straight off, without any preliminary studies or drawings. In the first two cases the painting was started simply because the model had naturally assumed a pose which seemed to lend itself to a painting. There was none of that rather laborious activity known as 'posing the model', trying one arrangement after another, moving the arms and legs about until the position looks more or less right. The paintings occurred as naturally as possible. Each was completed in two or three sittings. For a fairly small picture this seems to work out quite well—with the exception of the last one, these vary from 16 × 13 in. to 24 × 18 in. The first sitting shows the whole picture getting under way; it is reasonably safe, but there is still plenty left to do. In the final sitting, one is under a certain pressure the whole time, which is a good thing as it prevents that lazy, semi-automatic 'tidying up' which can take over if one has all the time in the world; for an an example of this, watch any life class of art students towards the end of the second week.

Painting a nude direct from the model is a classical subject, and one which painters have struggled with and enjoyed for many generations. If it is less common today, I can only feel sorry for those students and painters who spend their time at what seem to me to be far less fascinating substitutes! No other subject is so demanding as a nude. No other offers such subtlety of tone, and such tenderness of colour, besides the obvious difficulties of drawing, and the fact that any feebleness of construction will be instantly recognized. The modern-day painter sitting opposite his model can feel himself to be carrying on an immensely long and fruitful tradition as he struggles to translate solid three-dimensional form into an equivalent on his canvas. He is doing something which countless painters before himself have done, and is in exactly the same situation as Delacroix and Cézanne, Rembrandt and Renoir, in spite of the obvious differences of period and style.

**Figure 26.** Drawing of nude (black chalk heightened with white.)

I must admit that I enjoy this sense of a continuing tradition. I have worked on figure paintings from the model since I was a student and at every stage of my own development, and look forward to doing many more; for although the major part of my own work is done from drawings rather than direct from nature, none the less it depends fundamentally on this discipline of direct observation.

The first painting (Plate 7) is not a large one; it measures only 16 in. high, so it was quite possible to complete it in two sittings. It grew naturally out of several sessions in which I made drawings of the model—drawings made entirely for their own sake, with no other purpose. The painting itself was preceeded by a drawing of a similar pose, though this was in no way a study for the painting. I have lost track of this drawing and so am unable to reproduce it; instead I have included one or two others made at the same time.

While I was drawing this pose I noticed that the charm of the pose depended largely on a subtle effect of light from immediately above the model, who was lying back on a couch below the studio window. This light threw her head into shadow, while falling with soft illumination on her body. There was not a great deal of colour, but again there was considerable charm in

DIRECT PAINTING FROM THE NUDE

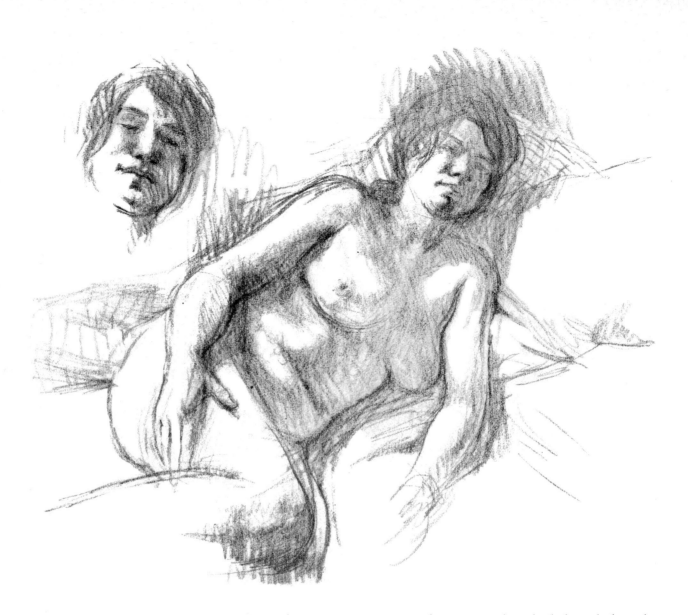

**Figure 27.** Drawing of nude (black chalk heightened with white.)

the contrast between pale ivory and pink flesh and the white sheets and striped pillows that surrounded her, quite without any conscious attempt at composition. The effect made one think of the French 18th century, of Boucher and Fragonard, and obviously had possibilities for a painting rather than another drawing, so the next stage was to select a canvas or panel from the stock that I always try to keep by me. Note that this was a case where I had no intention of beginning a picture when I started drawing that afternoon; it grew naturally out of something seen while I was drawing. So obviously it is a good thing not to be too fixed in one's ideas; on the other hand, there would not have been much point in starting a painting unless I had been certain that the model would be able to return for me to finish the picture.

There wasn't, as it happened, very much more time that afternoon. The light was beginning to go, and all I could do was to place the figure satisfactorily on the canvas and get the painting under way, so as to leave it in a nice stage for the next sitting. The first stage (Fig. 28) is no more, then, than a drawing done with

PAINTINGS IN PROGRESS

the brush and some raw umber thinned with turps, on the greyish canvas. I must admit that I like the result, as a drawing, a good deal better than some of the others I did that afternoon; I feel sometimes that it is a great pity that so many lively brush drawings of this kind are necessarily buried for ever under layers of oil paint!

The rest of the first sitting, with the light fading, was spent in rubbing in some areas of tone round the figure, and establishing some of the darker areas in the figure itself; and I was very careful not to let the painting get too light at this stage. I wanted to leave all the lighter parts of flesh and sheets until the next time, when they could be put in directly on to the dry, low-toned paint, working from dark to light—always an enjoyable process, as the light touches visibly bring the form to life and also look rich and attractive against the darker surroundings.

The painting grew fairly logically during the next afternoon sitting. I wanted to keep it rather unaccented in character, so I worked across many of the definite contours that you can see in the first drawing on the canvas. I always, in any case, try to avoid merely filling in outlines, and prefer to keep a process going of losing edges and coming back to them—re-stating them—

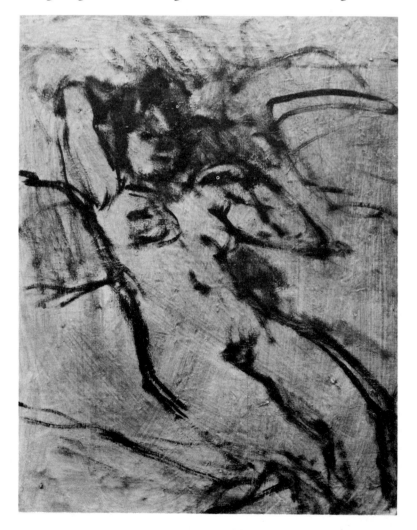

**Figure 28.** First stage of *Louise:* brush drawing on the canvas. This is the first stage of the nude shown in Plate 7. It amounts to a drawing done directly on to a grey-toned canvas with a hog brush and a little raw umber thinned with turps. Quite apart from being the beginning of a painting, this is a very enjoyable way of drawing in its own right.
The next stage after the drawing was roughly established was to scrub thinly some areas of darker tone round the figure.

**Figure 29.** First stage of *Jane*.

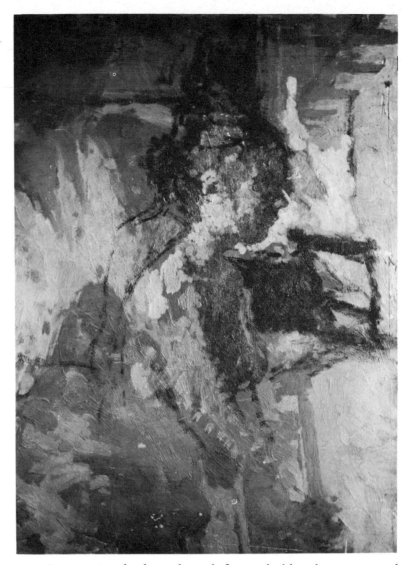

sometimes going backwards and forwards like this again and again. The pose taken up on the second occasion had inevitably some minor differences, and I incorporated these rather than risk disturbing the model's relaxation by a lot of pushing around. I usually do this, altering the painting rather than the model. I do regret a little, however, the alteration to the bent arm on the left. At the time I feel that changes of this sort are for the better, but it does not necessarily follow!

The second life painting (Plate 8) is similar in scale and tonality, but it developed in a rather different way. As you can see from the photographs, there was no placing of the whole figure on to the panel in the early stages. Instead, the painting began from a central point, the head, and spread outwards; the paint was handled in very small touches, placed side by side, without any preliminary drawing. Of course it was necessary to have a fairly clear idea in mind about what the final composition was going to look like.

The reason for such a different approach is largely because I was using an old panel which already had a picture on it. Every-

**Figure 30.** Second stage of *Jane*.

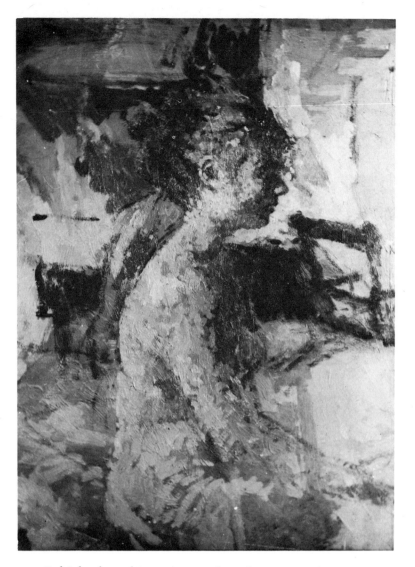

one, I think, does this at times, when there is no new canvas or panel of the right size to hand. There is very little harm in it provided that the new layers of paint are put on very solidly, and that there are no areas of very strong colour to paint over. It is, naturally, advisable to sandpaper down the old paint thoroughly. The comparatively dark and broken surface, with a good 'tooth' from the old layers of paint, is very attractive to paint on to; but it does mean that it is often difficult to draw with the brush freely, as I was able to do on the fresh, smoother canvas of the first picture; and so it seemed more natural to place small patches of solid paint like a patchwork, or mosaic, across the surface.

This is a good example of the way that one's materials can, to some extent, dictate the way one paints. A rough canvas or a smooth panel, a light ground or a dark one, a priming that is slippery to paint on or one that is absorbent—all these factors make a difference to the final painting that only a painter can recognize. So many writers on art, ignorant of the complexities of the medium and its often unexpected behaviour, tend to think that any change in a painter's handling must be a conscious one, and

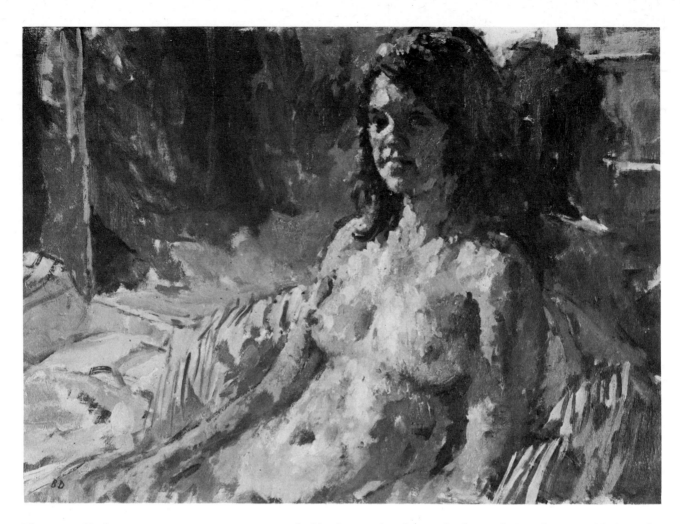

**Figure 31.** *Heather.*
20 × 16 in. approx.

probably the result of some 'influence'. It is far more likely to be fortuitous, and dictated largely by the behaviour of his materials.

The third picture (Fig. 31) is just as much of a portrait as a nude. There is no reason, actually, why a nude should not be a portrait, or vice versa, and there are some good historical precedents.

In this case the model is sitting up against the same mirror that was used in the previous example—a large one which used to be in a shop, and which I now have screwed to the wall. I have not used the reflection here to any great extent, except that the dark area to the model's left is formed by the reflection of the curtained window. I had, in fact, drawn the curtain more than half way across the window, as I wanted to reduce and concentrate the light that fell on the model. I wanted to paint a dark picture, with the subtle changes of colour that one can see on a light plane, such as the front of the thorax, in a low level of light, rather than the brilliant and somewhat harsh modelling produced by placing the model near the full light of the window. Many people talk as if every painter needed the maximum amount of light on every occasion. On the contrary, it is often necessary to keep light out of a studio when painting direct from the model, and curtains are an essential item in the studio furnishing. It is well worth

PAINTINGS IN PROGRESS

experimenting some time when you are in a large room, to see how the light can vary in the way it falls on a head. Try asking someone to sit close up to the window, and then move back gradually away from the light. The modulations become more subtle, and the play of colour more varied. In my own studio I find I am often too close to the light, as it is quite a small room; sometimes I place the model at the extreme end of the room to get greater subtlety of modelling. On the other hand, in the cottage room where I paint this subtlety is obtained by the relative dimness of illumination.

A word about models. I never use professional models—not that there are many of them about nowadays. It used to be a serious and honourable profession, sometimes continued through several generations of a family. I remember that when I was a student one of our favourite models was a middle-aged lady who belonged to an Italian family with a long tradition of modelling; one of her relatives, in fact, had sat to Gilbert for the figure of Eros in Piccadilly Circus. Nowadays the professional model is rare and art schools depend heavily on semi-amateurs, usually students or ex-students who do some modelling for a short period between jobs. In spite of greatly improved pay they are, no doubt, less reliable, and certainly can't stand up for hours on end like the old professional model used to do on his miserable pay. But I have always preferred to work from amateurs because they are likely to be fresher and not so set in their ways. Nearly all

**Figure 32.** *Heather*—the painting in progress.

DIRECT PAINTING FROM THE NUDE

Figure 33. Painting a demonstration
picture.

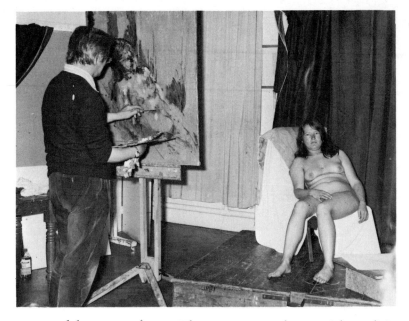

my models are students. There are several essential qualities
which a model must possess, quite apart from looks. One is a lack
of self-consciousness, which goes together with the mysterious
ability to move gracefully (I have a theory that the first-class
model looks bigger, and moves more naturally, out of her clothes
than in them). Then your model must enjoy sitting. Nothing is
worse than trying to work with someone who is bored and shows
that she is merely clock-watching. Finally, you should pay your
model properly. This saves you from worrying about whether
you are taking up too much of her time, or whether she is really
comfortable. I find that to work well I must have no distracting
thoughts about this sort of thing. I like to keep the whole session
friendly and even sociable, with conversation, cups of coffee, and
a relaxed atmosphere—which does not mean that I work with less
concentration.

I have occasionally come across artists who seem to regard
their models quite impersonally, almost as if they were merely
regrettable necessities. This would not suit me. I have always
felt the model to be a very important and, indeed, essential
collaborator.

The last painting I reproduce here is unlike any other in this
book as it was done as a demonstration, in front of a group of
students (they were amateurs; I cannot imagine doing this in an
art school—not nowadays, at any rate). This is, perhaps, not the
easiest situation in which to produce a painting. In fact I never
do it except on this particular course, where I have plenty of
time—three full mornings. If the painter is rushed for time and
expected to do something in a couple of hours he is almost
bound to over-simplify the complex process of building up a
painting, and rely on a formula instead—which, I should add,
students are all too likely to imitate. But as I try to avoid all
formulae, and regard the teaching of 'methods' as largely fallacious,
I prefer the demonstration to be as near my own natural way of

Figure 34. First stage, after the first sitting.
This demonstration painting had to be done
on much bigger scale so that the students
could see what was going on. The canvas is
a medium tone, serving for the time being as
a general half-tone for the flesh and
background. On this the figure is beginning
to be built up with touches of dark and
light.

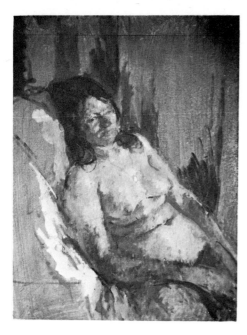

**Figure 35.** After the second sitting. The separate brush-strokes of the first stage are beginning to come together, and the modelling has developed considerably. The whole figure is being worked on at the same time. There is a continual adjustment of proportion and drawing going on, and none of the first judgements of width and position have been allowed to become too fixed. At this stage the forms are looking rather heavy; the head and arm, particularly, seem too large.

**Figure 36.** After the third sitting. This is as far as the painting from the model could go after three morning's work. It is by no means complete, but the drawing has continued to be adjusted and the proportions are now a little more satisfactory. Perhaps I worked too much on the figure—you will notice that the surroundings and background have hardly altered since the first sitting.

working as possible—which means a process of change, second thoughts, and plenty of time to look.

The main difficulty here was not the time at my disposal— though three mornings is not, after all, very long—but the necessity for working on a big enough scale for the audience to be able to see everything that was going on. This increased scale, a good deal bigger than my usual one, meant continual corrections and re-adjustments of the proportions.

I think some students who have a lot of difficulty with proportion may think that with time it will become second nature to judge correctly. I hope I am not being depressing if I say that it never seems to me to get any easier. Proportion has to be continually thought about and observed, and can't ever be taken for granted. In this painting it was made more difficult because there was not enough room to stand back and look at the canvas and the model together. The photograph shows how close to the model I was working.

The picture was not finished in the three sittings; but I preferred to leave it in its sketchy condition rather than attempt to complete it afterwards.

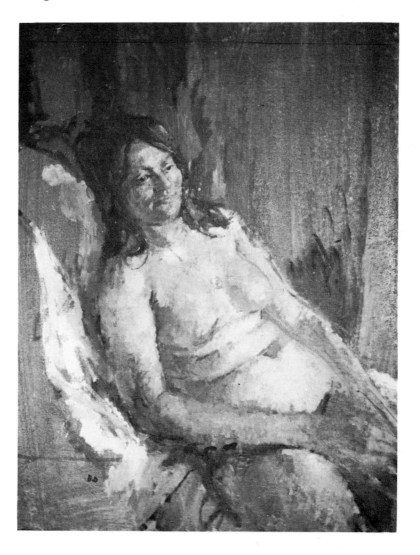

DIRECT PAINTING FROM THE NUDE

# 5 Townscapes

The series of pictures that I now want to discuss is a little different. The pictures are linked together largely by being of the same place, but the lighting and viewpoint is different in each instance. However they do form a true series because the thought behind each one is continuous. They share, too, an upright format. In contrast to the cottage interiors, they deal with different aspects of one huge place, the Campo at Siena.

The Campo is the main square of the town. Strictly, it is not a square at all, being D-shaped, and it has a slightly sloping and concave surface paved with a light pinkish brick. A wide footpath goes round the curved part of the D, while at the bottom, where it slopes down towards the Palazzo Pubblico with its slender, lily-like tower, there is a road, kept largely free from traffic. So the whole great area, surrounded by tall, pink brick buildings, is open to the pedestrian, and its warm and inviting surface is hardly ever without groups of idlers, mothers with children and prams, and pigeons. The only comparable place I know is the Piazza San Marco in Venice. But the Campo has a more intimate, more workaday mood than the 'drawing-room of Europe'; it is more like a front doorstep, for there are always children playing, and its cafés are comparatively modest affairs. I must admit that for a long time it has been an ambition of mine to live for a while in Siena, and to be able to stroll in the Campo every morning and evening.

It is clear, then, that these paintings of Siena are similar in another way to the cottage interiors, in that they reflect a place where I feel at home. As I mentioned before, I cannot be detached about the subject matter that I paint. If I paint people I prefer to have some feeling about them, and I wouldn't want to paint a place at all unless I felt at home and happy in it. Some artists have felt that they should not be too involved emotionally with their subject matter. Sickert is an example who comes to mind; he recommended that one should always use paid models, people in whom one had absolutely no personal interest. For my part,

**Figure 37.** *The Campo: children and pigeons*
9 × 6½ in.

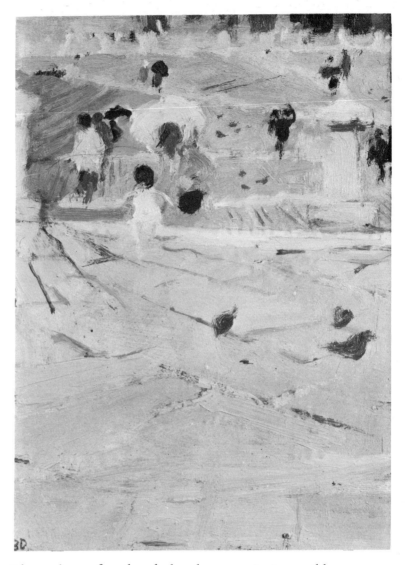

**Figure 38.** Drawing for Fig. 37. This small picture, an early attempt at the subject, resolves itself into a pattern of light and dark spots against calm areas of grey and pink. The umbrella held by the figure near the centre is a bright pale pink, and this relation of pink against rosy violet brick paving in the foreground was the starting-off point of the picture.

I have always found such detachment quite impossible.

Every time I go to Siena I do more drawings of the Campo, in every possible light and at every time of the day. The first paintings I made (Figs. 37 and 38) concentrated on the beautiful colour harmonies made by light and dark clothes against the tender pink of the brickwork, which can become violet or greyish according to the light and its angle. The lines of white stone paving which run towards the centre of the Campo are very useful for dividing the space; and I liked as well the contrast between the pavement and the brickwork. Looking back on these first attempts, I feel they are too difficult to 'read'—it isn't easy to understand the planes and surfaces. In later studies I took a larger view, so that there was always some hint of the buildings and pavement on the other side. (Figs. 39 and 40).

These paintings, like all those I do of Italian towns, are painted in the studio afterwards from drawings, I never attempt to open my paintbox out of doors, unless I am well away from the town out in the landscape, because I know that to start painting in the street would immediately collect a sympathetic crowd, including a

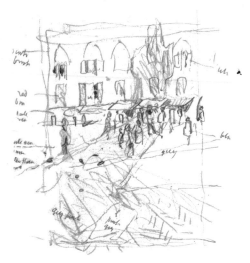

**Figure 39.** This page from a sketchbook is the drawing from which Fig. 44 was painted some time later. As you can see I altered the position of the figures and added the pigeons in the foreground, but the essential elements are all here. The colour notes were important, as the relationships are extremely subtle.

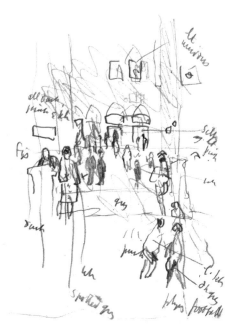

**Figure 40.** Drawing from a sketchbook.

number of those little boys who seem able to pop up out of the ground and have nothing to do but to watch you, getting very close, for hours on end. Using a small sketchbook, however, one can draw for quite long periods unnoticed. I either sat at one of the numerous café tables, or stood unobtrusively to draw. If you want to become still further invisible, you can try holding your sketchbook behind a folded newspaper.

In passing, I might mention that I use a standard size sketchbook which I have been using for years, exactly the right size for the pocket and the right thickness as well, so that it is stiff enough without being heavy. I had these sketchbooks made up for me by a printer. At the time I remember being rather bothered when I heard that they would not consider an order of less than 100; when I saw the parcel of sketchbooks, I thought they would last me the rest of my life, but actually they have all been filled over a period of about ten years. Each book contains 18 pages, and I reckon to use three or four during a short painting trip. When I had finally used them all up and ordered some more, I found that the cost had risen so much that I now make my own, having acquired a large office stapler. It is a temendous advantage to be able to keep a row of such sketchbooks on a shelf, and to know that you can put your hand at once on a drawing of any period.

It is surprising how much information can be packed into a very small drawing of this kind. As you can see from Figs. 39 and 40, I make colour notes on the drawing, using a kind of shorthand, and also make additional studies of the changing groups of figures. Fig. 41 shows a rather more complete drawing, done no doubt in the relative comfort of a café chair. I also take a photograph, an ordinary black and white one, which can come in useful later on as an additional aid to the memory, though I try to avoid painting with it in front of me.

If the drawing is sufficiently informative it should even be possible to take it out again years later, when all immediate recollection of the scene has faded, and produce a reasonable painting from it. There is no doubt that a drawing can have the property of, so to speak, recalling one's buried recollections of the scene, apart from the actual information it contains. This must depend on the artist's individual capacity for subconscious visual memory, which probably varies very widely.

Turner, for instance, must have had one of the most phenomenal memories in the whole history of art. It is said that he was able, on turning up a mere scribble on a scrap of paper done thirty years before, to reconstruct the whole scene in considerable detail; not only that, but to reconstruct what it would have looked like as seen from a different viewpoint. Obviously, a power like this cannot merely be called memory; it is a quite indefinable and gigantic intellectual and imaginative grasp which would make a computer look silly.

As ordinary painters we can never hope to have anything like this kind of grasp. We have to make rather complete drawings, cover them with notes about the colour, and hope that they will

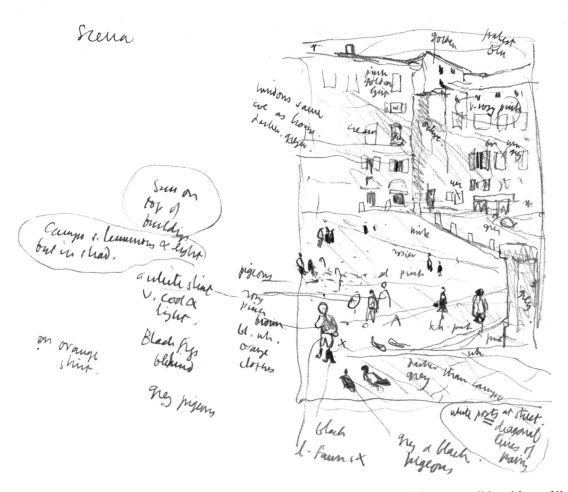

**Figure 41.** Drawing from a sketchbook.

give us enough information, and that we will be able to fill up the gaps successfully. A very minor example is shown in Figs. 42 and 43. The drawing was done almost exactly ten years before in Dieppe. I came across it in an old sketchbook while looking for something else. I had never done a painting from it, and thought it might be interesting to see what came out. I did not attempt to go beyond the comprehensible information that the drawing could give me. Where I couldn't understand what was going on, I merely put down marks on the painting which related to marks in the drawing, without bothering too much about what they stood for.

To return to Siena. The shadow of the campanile of the Palazzo Pubblico moves like a sundial across the Campo, and divides the space very usefully (Fig. 44). Here the diagonal can be used to contrast with the generally horizontal directions, and the change of tone from light to dark is similarly useful. As the sun sinks, the Campo itself becomes shadowed by the tall buildings around it, but this shadow is essentially a very luminous one. The light brick paving and the huge area of sky above prevents it from ever appearing dark or gloomy. I liked very much the effect which I noticed one day of one brilliantly sunlit building glimpsed along a narrow street, past shadowed houses (Fig. 45). This presented a subtle problem of values later when I came to paint it, as the general tone of buildings and paving had to be low enough

**Figure 42.** *St. Jacques, Dieppe* 8 × 9 in.
(Collection of Mr D. F. L. Cooke.)

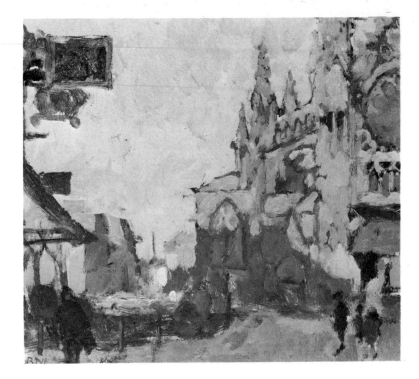

**Figure 43.** Drawings of St Jacques,
Dieppe.
The drawing started at the extreme right-
hand side of the page with the complicated
shapes of the window traceries. Dark
accents are put down clearly, and the lightest
parts in the building are also noted. When
I reached the far side of the paper I had to
move to another page to do a separate
drawing of the left-hand side of the street,
with the unexpected shapes of the hanging
signs.

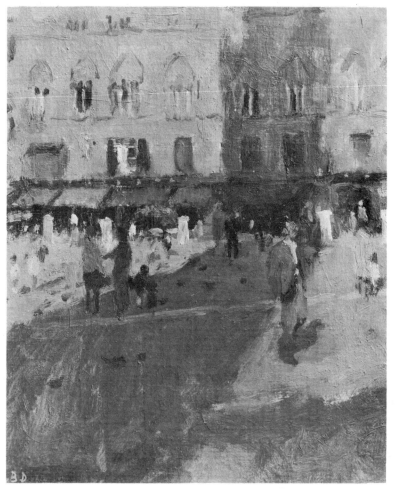

**Figure 44.** *Siena, the Campo, morning*
10 × 8½ in.

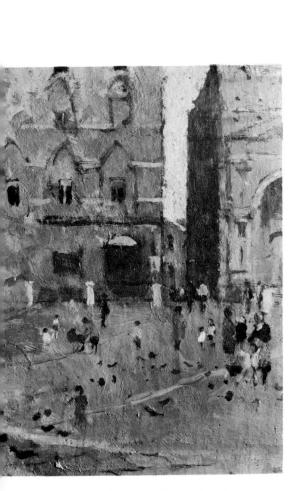

**Figure 45,** *Siena, the Campo, late afternoon*
12¾ × 9½ in.

to allow the lit wall to sing out, while retaining their luminosity—a Sickertian problem.

As the dusk falls, the light accents of white or pale-coloured clothing seem to glow against the paving, which becomes almost violet-grey. The dark accents, too, look very rich and soft. I have tried several times to do something with this evasive quality of light. Looking up from the Campo to the slope which leads up to a busy shopping street, crowded with strollers and groups of men talking, one sees a fascinating combination of soft luminous whites and greys accented by the sharp, warm lights of shop windows and street lamps. Whistler, as well as Sickert, would have enjoyed doing something with this. All these scenes of the Campo, but more particularly the twilight studies, rely considerably in their execution on the use of a general tone—a pinkish violet or greyish all-over harmony. To quite a large extent they are painted in terms of a rub-in, keeping the tones very close together, with directly painted touches of fat paint on top, 'writing in' the figures and the architectural detail.

This was, roughly speaking, Sickert's method, used in his finest Venice and Dieppe pictures of 1900–1905, and was itself a development of Whistler's and Degas' methods. The picture might start with a linear drawing—almost a map—of the main

TOWNSCAPES

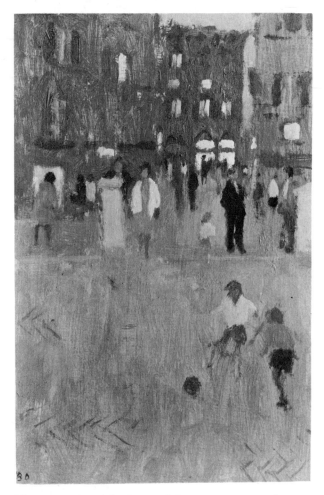

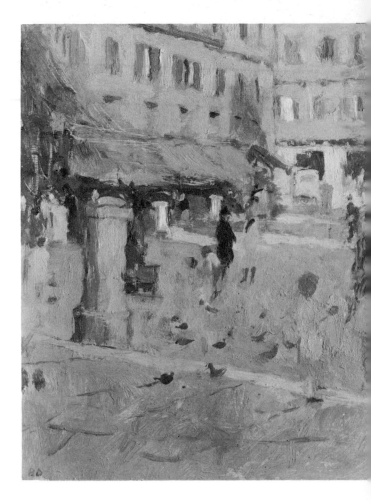

**Figure 46.** *Siena, the Campo, dusk*
$11\frac{3}{4} \times 8$ in.

**Figure 47.** *Siena, the Campo, afternoon*
$11\frac{1}{2} \times 10$ in.

shapes and points of interest. Then the larger areas of tone would be scrubbed in (as Sickert graphically described it, 'like a man wiping butter off his boots') so as to cover most of this scaffolding with roughly brushed masses with no hard edges. This would be allowed to dry well. Finally, fat, definite touches would be placed over this foundation, with vigorous re-drawing and definition of detail.

On our last visit to Siena we were, for once, unlucky with the weather. It rained nearly all the time. In spite of this I was able to make some studies. The familiar scene of the Campo was altered by the number of umbrellas; the Italians are great umbrella carriers, and the dark or brightly coloured shapes made useful silhouettes (Fig. 49). In spite of the lack of sunshine, the colour is still charming.

My last reproductions (Plates 10 and 11 and Fig. 50) are not of Siena but of Venice—probably the best city of all for painters, due at least partly to the lack of cars, but also obviously to the great variety of paintable buildings. It may sound silly, but one reason why Venetian buildings lend themselves so well to being painted is that their windows are manageable. Instead of rows of identical windows, each one with its network of glazing bars, there are varied and beautiful shapes, often irregularly placed in the facade, which do not need precision drawing.

PAINTINGS IN PROGRESS

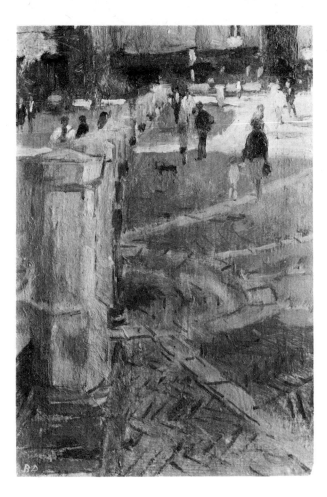

**Figure 48.** *Siena, middle of the Campo, morning* 13 × 9 in.
At the middle of the Campo all the lines of white masonry converge. This pattern, with the line of posts coming into the foreground, occupies the whole of the lower two-thirds of the picture. All the figures, which give scale to the whole scene, and the sunlit patch of paving which lightens the tone of the picture, are kept within the top few inches.

**Figure 49.** *Siena, Umbrellas in the Campo* 11 × 7 in.
On a wet day the scene is altered by the silhouettes of umbrellas. Notice the variety of scale in the figures. Beyond where the two men with umbrellas are standing, there is a dip in the ground level which makes the more distant figures appear much smaller than one might expect. It is sometimes quite difficult to explain this kind of thing in a painting, but it is probably better to leave oddities rather than try to tidy them up too much.

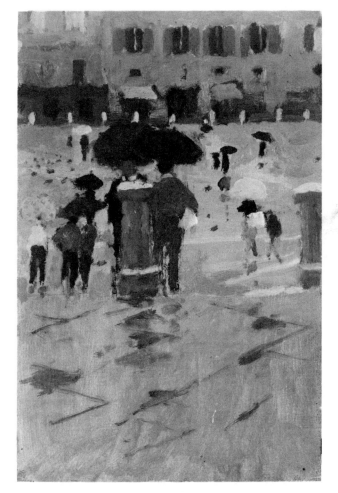

TOWNSCAPES

**Figure 50.** *Venice, Campo San Stefano II*
12 × 10½ in.

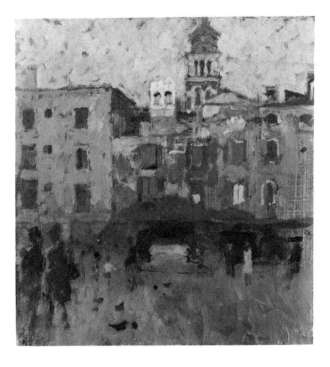

These Venice pictures are all of the same square, and I put them in here to show how by merely changing one's viewpoint, even staying in the same place and turning round, it is possible to find enough variety of subject to keep busy for days. The drawings were made in the Campo San Stefano in one late afternoon. The first (Plate 10), at one end of the square, shows a narrow alley leading off it with a café in the foreground. The second view (Fig. 50) is at exactly 90° to the first from practically the same pitch, and the third (Plate 11) represents another 90° turn, so that we are now facing in the opposite direction.

# 6 Hotel rooms

I have already devoted one chapter to painting the figure in a
setting that is thoroughly familiar and understood. In my own
work there is another kind of room which forms a background
and a setting for pictures: the hotel room. In contrast, this is a
temporary and continually changing environment.

When I am in Italy or France on painting trips, I tend to find
as many subjects in the hotel rooms we occupy as I do in the town
outside or in the country. We always stay at small and modest
hotels, and I am inclined to look at the room as much from the
point of view of its colour and light as from any other, possibly
more important, considerations. Nowadays such rooms do not
vary much from an almost standardized pattern. It is very rarely
that we come across an old-fashioned pretty room with painted
furniture or interesting wallpaper. (There is still more wallpaper
in France than in Italy, though.) However, the differences are
still there, despite the almost universal plain light walls, white
washbasin and shutters, and are sufficient to ensure that I never
get tired of this subject and look forward to a new town with some
anticipation. There is even a kind of fascination in seeing how the
same elements can create a slightly different composition in every
room. Just as Morandi paints picture after picture using the same
bottles and jars in slightly different groupings, so the painter of
interiors will ring important but subtle changes in such elements
as the mirror over the washbasin, the design of windows and
shutters, or the lighting arrangements.

A good hotel room from the painter's point of view need not
necessarily be the cleanest. It may even be one of those that we
leave, after a night or two, for another more salubrious one in
the same town. Often a beautiful chord of colour can be dis-
covered in spite of shabbiness—possibly warm brownish walls in
opposition to the cool whites of towels, bed-linen and tiles, those
whites which form a constant accompaniment to the other
colours.

Sometimes there will be a view from a window, with red

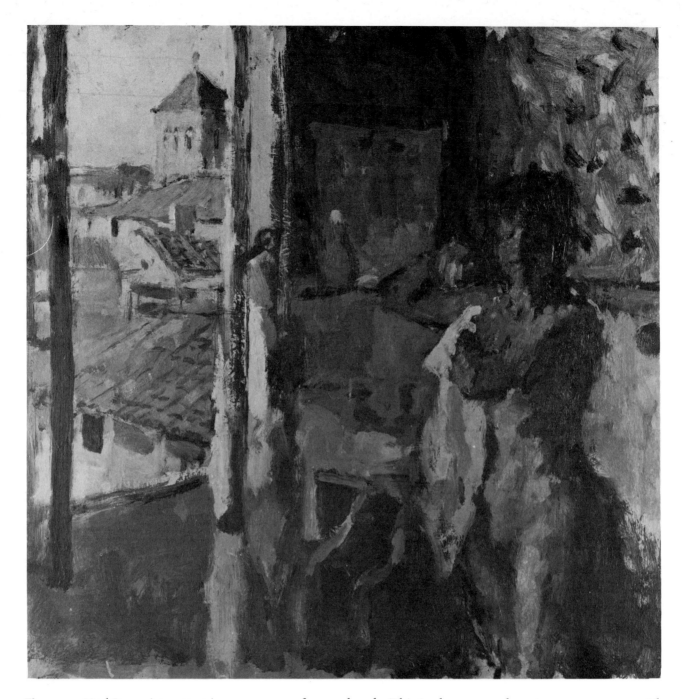

**Figure 51.** *Hotel Room, Apt* 11 × 10 in. approx.
The first impulse behind this small painting was the warm golden evening light on the buildings, with the whole foreground in cool shadow. It was carried out quite quickly from a rather full, careful drawing on a subdued purplish-pink ground, which is allowed to show through between the comparatively loose brushwork.

roofs or a church. This is always worth trying to compose, with its tricky tonal relationship and, if a figure is involved, its fascinating juxtaposition of interior and exterior space. Who could resist a subject like that? The colour plate (12) shows a typical example of a subject which could become over-sweet—a danger always to be watched. The only way to avoid this pitfall when dealing with such an obviously attractive theme is a rigorous attention to subtle relations of tone, colour and drawing, never allowing oneself the slightest forcing. I prefer, indeed, to understate; it is so fatally easy to push a tone or a colour just a little beyond its natural and eloquent position for the sake of making an expressive point, though this is more often than not lost

PAINTINGS IN PROGRESS

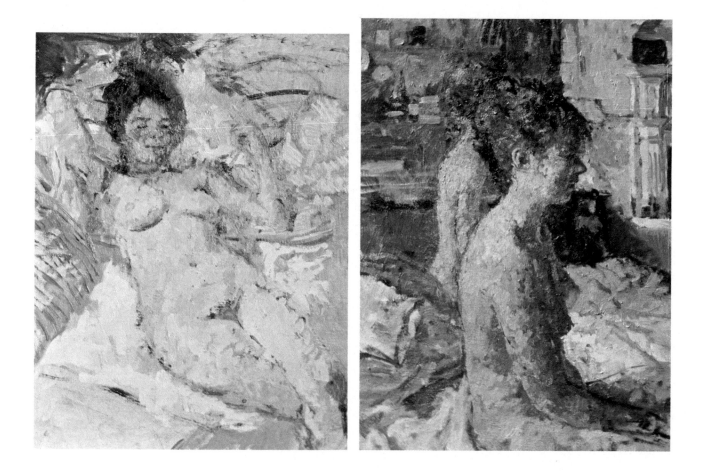

**Plate 7.** (Left) *Louise* 16 × 12 in. approx. This small painting was completed in two sittings. Every touch was put on while the model was sitting, avoiding the temptation to go on and 'tidy up' the paint after the sitting was over. The painting developed more or less from dark to light, with the final touches kept solid and full over areas of paint scrubbed in fairly thinly.

**Plate 8.** (Right) *Jane* 18 × 14 in. approx. Although this is another rapidly painted study direct from the model, it developed in a rather different way. It was painted on an old canvas, over a dark picture, so the fresh paint had to be applied in separate, solid touches, like a patchwork.

It is always interesting to pose a model in front of the large mirror on the studio wall. The colour of the reflection often shows unexpectedly different variations.

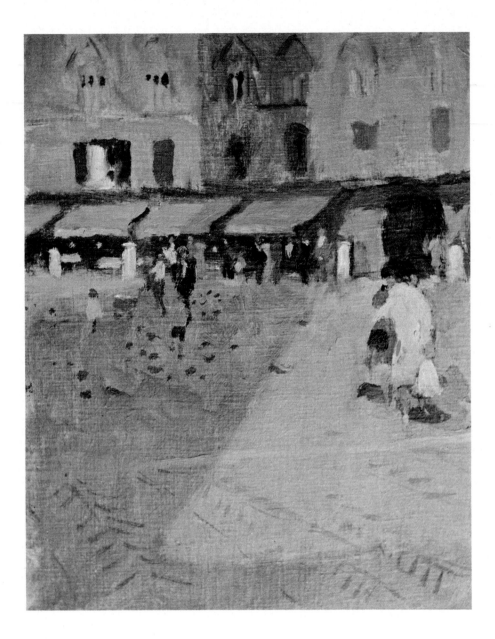

**Plate 9.** *The Campo, Siena* 10 × 8½ in. The shadow of a campanile falls across the Campo, dividing it into areas of light and shadow, across which figures are continually passing. There is a tremendous sense of space in the open square, and this is emphasized by the big difference of scale between figures in the foreground and the distance. Children, pigeons, people, and the white stone posts which line the edge of the Campo, all make a lively pattern against the huge area of paving.

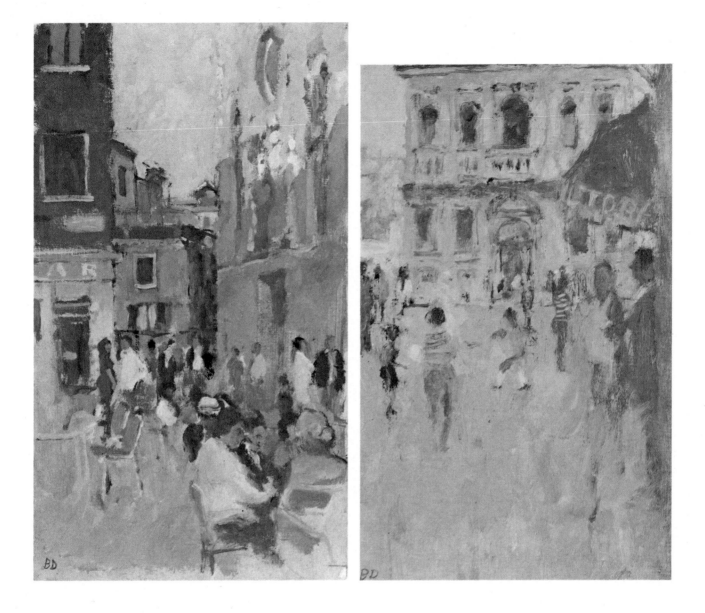

**Plate 10.** (Left) *Venice, Campo San Stefano: Calle delle Botteghe* $14\frac{1}{2} \times 8\frac{1}{2}$ in.

**Plate 11.** (Right) *Venice, Campo San Stefano III* $11\frac{1}{2} \times 7\frac{1}{4}$ in.

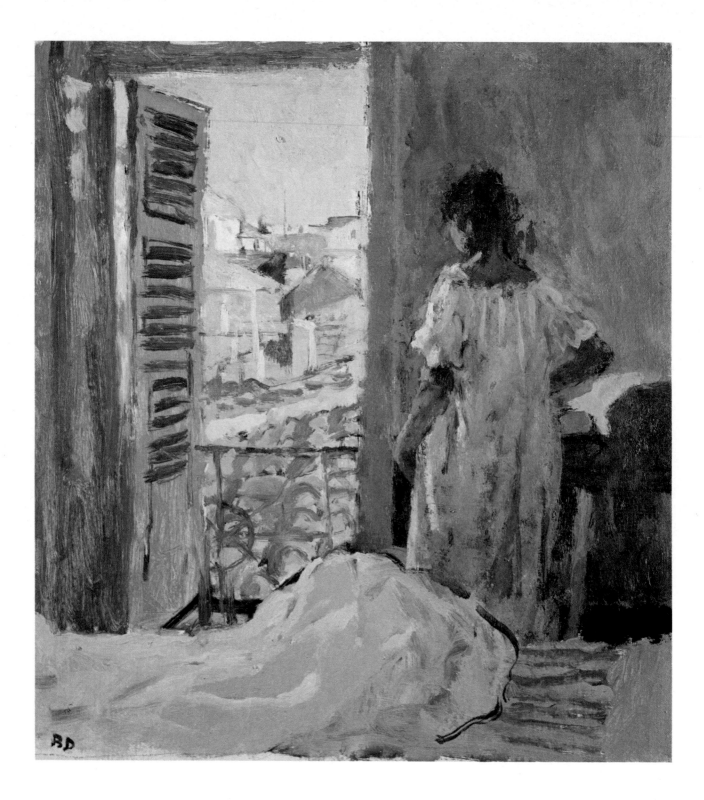

**Plate 12.** *Viterbo, Morning* 12 × 11 in. This painting shows a simple warm/cool opposition of colour. The interior is mostly cool, with a few warm notes, such as the flesh. The view through the window, on the other hand, is mostly warm and glowing in colour, with the blue of the sky making a colour link with the interior. These echoes of colour make links from one colour area to another, and avoid any monotony. (Collection of Mr Julian Agnew.)

through over-statement. In this respect I have often thought that Gauguin did an immense amount of harm when he made his famous stupid dictum: 'If you see a green, make it as green as you can'. Gauguin's actual colour is often remarkably restrained, but through remarks such as this he must have inspired whole acres of insensitive and exaggerated colour from others.

It is necessary, for instance, to resist the temptation to force the colour of the light walls seen through a window, as in Fig. 51. One has to look very hard at their true relationship when compared to a light area inside the room, i.e. the light side of the nightdress, or the flesh.

In doing several of these pictures, which are largely built up in the studio from drawings, I have been so careful to get this relationship between indoors and outdoors right that I have worked a little on the panel on the spot, rather than rely too heavily on the information in my drawings. Sometimes just a few touches of colour will be a very valuable guide when one comes to develop the picture later on in the studio.

Plate 13 and Fig. 52 show similar rooms in the same hotel, one at which we often stay. As a matter of mere economics it is

**Figure 52.** *San Cimignano, balcony room* 15 × 12 in. approx. (Collection of Lord Hirshfield.)

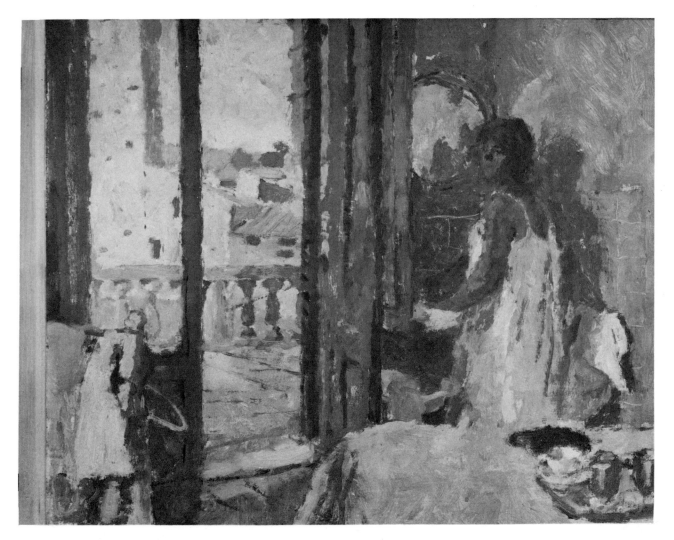

HOTEL ROOMS

**Figure 53.** Original drawing for the figure in Fig. 54.

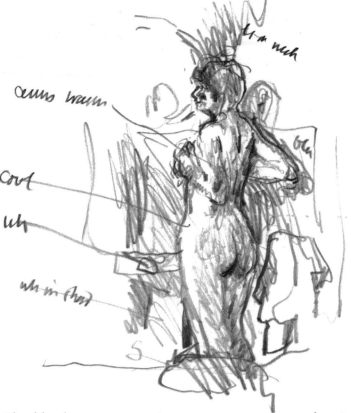

considerably the most expensive one we ever stay at, but it is well worth it because of the charming setting these rooms provide, with their painted furniture, shuttered windows and superb views over the town and the Tuscan countryside.

Having done several small paintings in this room I decided it was time I tried something a little more ambitious. I find that my attitude towards larger pictures alters at different times. Sometimes I have a period of tackling quite large and ambitious compositions, like those discussed in the chapters on bathroom pictures and figure composition. Then for some months or a year I may work only on a small scale. I find that the small pictures go on all the time, as an absolutely natural form of expression. But I have always been aware of the danger of concentrating too much on a small scale. Difficulties can be skated over in a small picture which have to be faced and worked out as soon as one embarks on a bigger size. So big pictures, even if they turn out to be absolute flops, can be a tremendous help to the rest of one's work in the way that they force one to extend one's range and to tackle complications of design and construction. However, the actual scale of these more ambitious efforts, as I have suggested, can vary a lot. I often find difficulty in working on a middling size picture such as 20 × 24 in. or 30 × 35 in., preferring either a small panel or a canvas of four or five feet. There is one thing these two extremes have in common. On the small panel your natural mark or brushstroke comes from the hand, in a wrist or even a finger movement. On the big scale, this touch is enlarged to become an arm movement; you have to stand up to the picture,

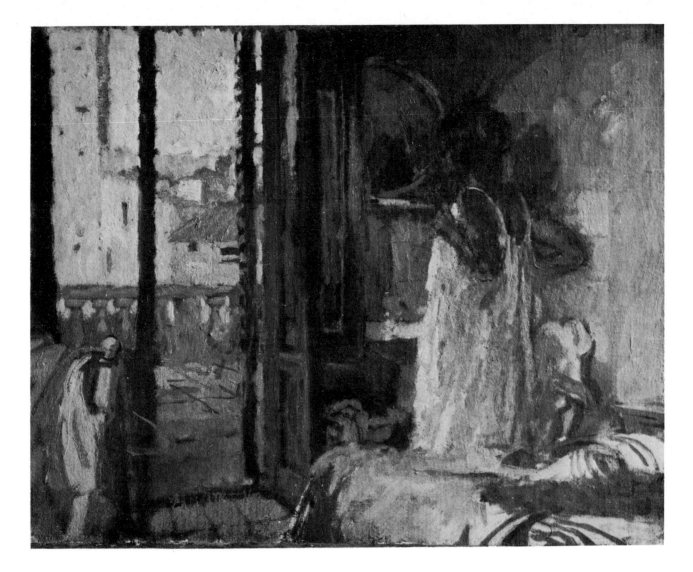

**Figure 54.** *San Gimignano, balcony room* (larger version) 22 × 18 in. approx.
This is a larger version of the room used in Fig. 52. A view through a window, linking the inside of a room with the world outside, is unfailing in its fascination for the painter, but needs very careful handling because the contrasts of tone are so great. One has to try to give an impression of brightness contrasted with dimness without exaggeration—in fact it is nearly always necessary to keep the tones a little closer together. The striped pattern on the bedspread, enlivening the right-hand corner, was a useful afterthought here.

and almost feel yourself moving about within it. You can work from side to side with an arm movement, just as in the small picture you go from side to side with the wrist. In both cases, you are painting freely. But I often find that the middle size inhibits me because it is neither one thing nor another, and my attempts on this scale have often become stodgy and lacking in variety and freshness of touch.

So every now and then I consciously attack this middle size, and recently I have been doing a certain number of what I call 'big small pictures'. These may be around 24 × 20 in.; very small by some standards, but sufficiently larger than my usual small panels of about 10 × 12 in. or so to make quite a lot of difference.

Fig. 54 shows one of these slightly larger versions of the same room in San Gimignano. I had a choice of several drawings to work from: a nude (Fig. 53) and at least two featuring a white nightdress. As I had already used this in a previous picture (Fig. 52) I decided to choose the nude version. Figure 55 shows a very early stage. The basic colour of the panel was a middle blue-grey tone. The first rough drawing with the brush, showing the main

HOTEL ROOMS

**Figure 55.** First stage of Fig. 54.

divisions of room and window, and the placing of the figure, was not materially departed from, although other important changes were in the offing. Figure 56 shows the panel after the whole surface had been developed and worked on. I had been having some trouble with the figure. Her scale seemed to be getting slightly out of hand, and this meant that I was not sure there was, after all, room for her legs. However, I was interested in the way the shapes around her were developing. I felt a need to push the figure slightly over towards the left, so that she was not so much in the middle of the space between the window and the right-hand side of the rectangle. The colour also dissatisfied me at this stage; it seemed a little stodgy, and I was tempted to try the

**Figure 56.** Second stage of Fig. 54.

PAINTINGS IN PROGRESS

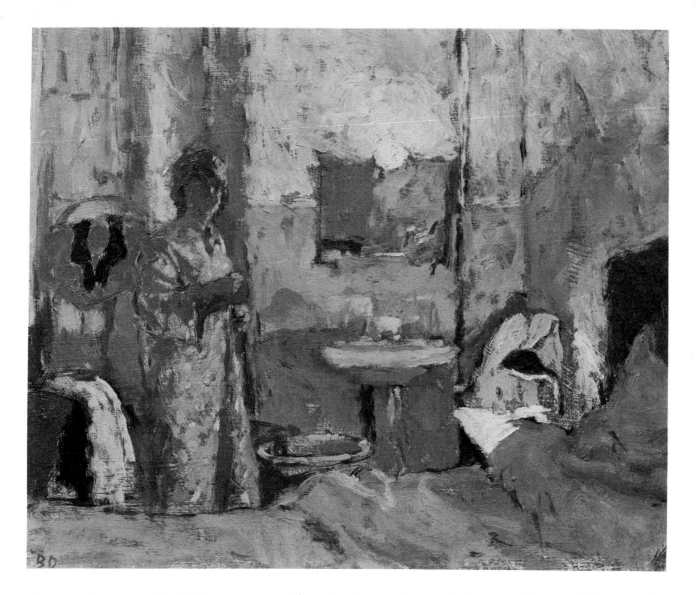

**Figure 57.** *Siena, room with bedside light*
12 × 13½ in.

effect of a white, rather pearly in the half shadow. This seemed to work, and developed naturally into the white nightdress that you can see in Fig. 54. From this point on the picture 'finished itself' without too much difficulty.

At night, with the lights on—preferably only the small bedside or mirror light, so that the illumination is concentrated—any hotel room, however prosaic, can be transformed. Figure 57 is an example. The reading light is the main source of illumination, and much of the figure is in shadow. The composition becomes, to some extent, a matter of holding together a number of scattered shapes by means of the unifying effect of the light.

A figure under these conditions will very often be seen against the light, as in Fig. 58, where the light over the mirror is the main source of illumination. Again, very careful observation of the tone of the shadow side of the figure, finding exactly the right degree of silhouette and the way the tone merges with or stands out from its surroundings, is essential.

There is no second chance with most of these hotel pictures,

HOTEL ROOMS

unlike the everyday familiar interior where fresh studies can be made when necessary. Your drawings have got to give sufficient information. At the same time, I feel more free to improvise than I would when using my own room, and have no hesitation in using a comparatively arbitrary colour scheme or altering the colour of a wall. Whatever liberties of this kind I allow myself, though, I find that I invariably stick to the tonal pattern—the distribution of light and dark areas—of the original study.

You will notice that in all these pictures in which I have painted

**Figure 58.** *Room in Siena* $11\frac{1}{4} \times 11$ in. (Collection of Mr H. Ilsen.)

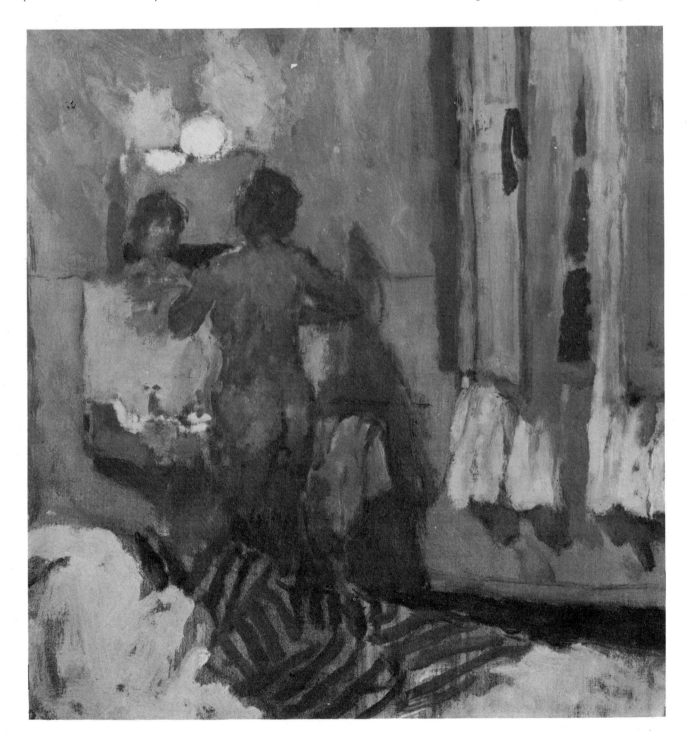

PAINTINGS IN PROGRESS

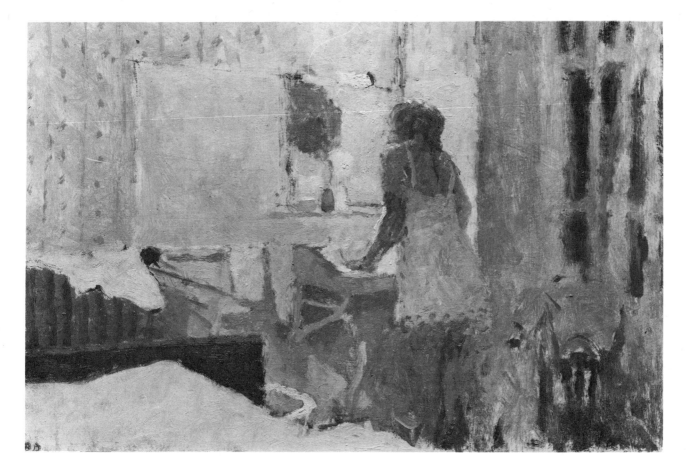

**Figure 59.** *Pont-en-Royans* 14 × 10 in.
approx.
A room at night, lit by electric light, can
present the painter with a totally new set of
silhouettes and shapes. The bottom left-hand
quarter of this picture, for instance, with
the shapes of the basin, towels on the rail,
radiator and bed, makes an interesting and
complex set of shapes and directions,
contrasted with the empty wall above and
the dominant silhouette of the figure.

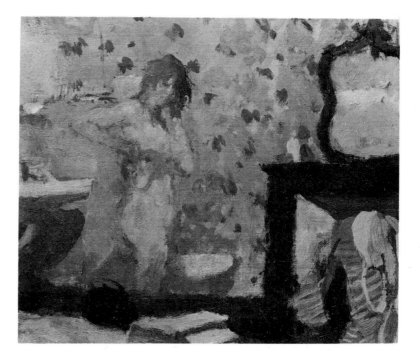

**Figure 60.** *Room with mirror, Apt*
10 × 11¼ in.
This is another picture using artificial
lighting. The rather charming room was
dominated by the fireplace and mirror, and
this strong dark shape was allowed its full
strength. In contrast, the nude figure is
practically without accent, and almost
'lost' against the wallpaper. The colour also
contrasts tender whites, pinks and grey-blues
with the stark brown and black shapes on
the right. An even blacker handbag on the
bed echoes them.

HOTEL ROOMS

my wife as the figure in a hotel room interior, she is either nude or wearing very simple clothing—a nightdress, a slip, or a dressing gown. These garments do not date, quite apart from their intrinsic charm. I must admit to feeling uneasy if, ten years after it is painted, a picture looks odd because a hemline dates it. I know perfectly well that after a long enough interval such things will not matter at all, but I still prefer to paint subjects which don't become unfashionable—one of the many reasons, perhaps, for painting nudes.

Apart from this consideration, the simple, luminous white tone of a nightdress, as in Plate 12 and Fig. 52, is almost irresistible as a subject. Another garment which seems to turn up very often in these pictures is a slip of a soft tan colour, almost the colour of tea; this can be seen in Fig. 59.

# 7  Musicians

It has always seemed to me a pity if one's method of painting restricts one to a certain range of subject-matter. Ideally, perhaps, an artistic method should be flexible and supple enough to deal with every possible subject. My own range is not very great but I do like to be able to say something in terms of painting about everything that interests me in life. As music is one of my main interests, I naturally try at intervals to do paintings of musical subjects—orchestras, chamber music, and conductors.

I seldom go to a concert, in fact, without being tempted to make a drawing or two on the programme. The complex groupings, the beauty of the instruments themselves, the expressive gestures of the players, as well as the association with the music, make a string quartet, for example, an irresistible subject, and one that is always different according to the particular character of the hall or the position of one's seat.

Over the years I must have accumulated dozens of little studies like Fig. 61. The difficulty here, of course, is that one is usually sitting quite a way from the performers, even if one chooses a seat at the side of the orchestra. The drawing is likely to be on a very small scale, and yet it is necessary to pack in as much information as possible. This particular study may seem rather difficult to 'read', but it was sufficient—with a few other similar notes—to carry out the small picture (Fig. 62).

After trying to draw from the body of the hall like this, it is a great pleasure to be able to get into orchestral rehearsals, and actually sit and draw among the players. Needless to say, this must be done with great discretion and with the full knowledge and approval of the conductor. One must work as quietly and self-effacingly as possible, only moving about when there is a break. The orchestral players are invariably interested and sympathetic to someone in their midst who is doing as specialized a job as they are themselves.

It is possible to make much more complete and informative studies at close quarters. Figure 63 is the first drawing I made in

**Figure 61.** Drawing for *Mahler's 4th Symphony.*

**Figure 62.** *Mahler's 4th Symphony* 9 × 7 in. approx.

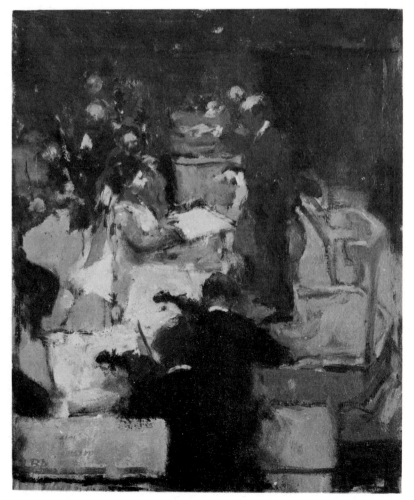

*Facing page:*

**Figure 63.** Drawing made at a rehearsal.

**Figure 64.** *Rehearsal of BBC Symphony Orchestra* 10 × 12¾ in. approx.
This painting follows the drawing done at rehearsal almost exactly, even in its composition and placing. The woodwind players on the right and the brass on the left are separated by a row of music stands. I began the drawing, in fact, at the point where the music on the stands overlaps the clarinet, bassoon and double-bass players. The silhouettes of the latter are very important in the composition. The colour range is from golden-brown and the bright gold of the brass instruments to the blue-green of the wall behind them.

PAINTINGS IN PROGRESS

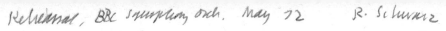

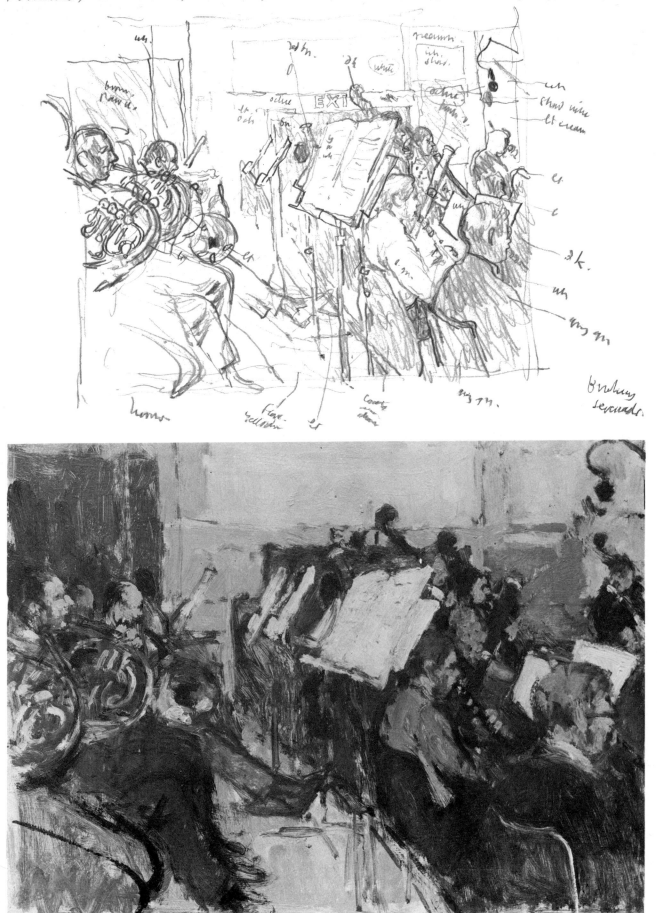

75

**Figure 65.** *BBC Symphony Orchestra rehearsing with Colin Davis* 11 × 11 in. Here the starting-off point was the way that the harps frame the whole scene, making big dominating foreground shapes. Musical instruments are invariably beautiful in their shape and colour, and to me it is absolutely essential to get them 'right'.

one morning's session and is rather more thorough than most of its successors. Whether for this reason or not, it forms a rare example (for me, at any rate) of a study in which the whole composition has been worked out on the spot. The finished picture has, in fact, been designed in the course of doing the drawing, and as you can see by comparing it with Fig. 64 the painting hardly differs in a single detail from the drawing.

However, I must emphasize that it is certainly not merely a matter of 'copying the drawing'. Although there is a good deal of information about shape, tone and colour contained in the

PAINTINGS IN PROGRESS

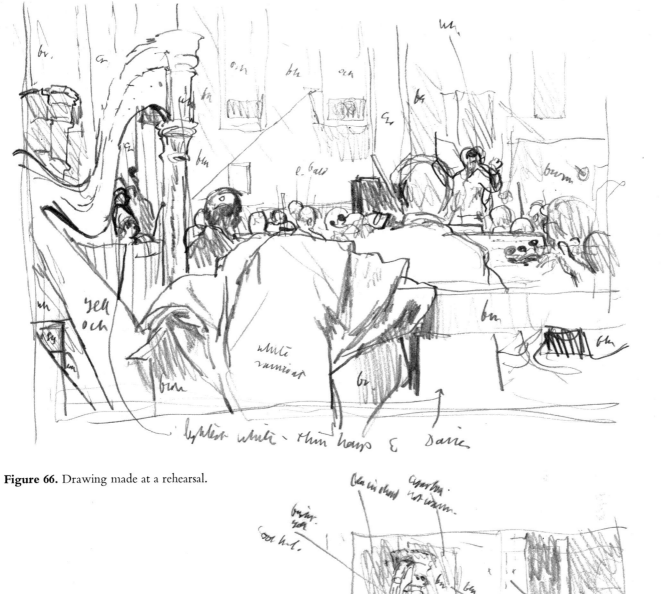

**Figure 66.** Drawing made at a rehearsal.

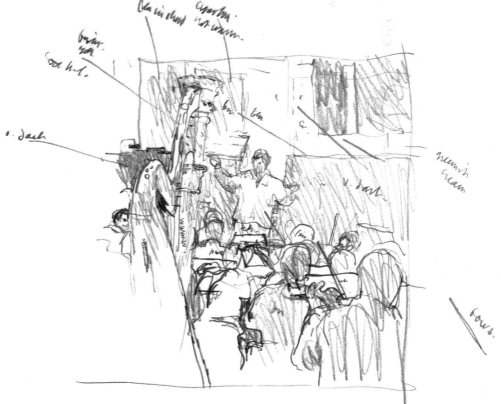

**Figure 67.** Drawing made at a rehearsal.

drawing, one is continually having to make decisions at every stage of working from it. Quite apart from the colour, where there is obviously room for manoeuvre, small alterations of tone can have important effects; two dark areas can be linked, for instance, by keeping their values the same; an edge can be sharpened to emphasize a direction or rhythm, or another shape can be slightly 'lost'.

In fact, from this one drawing it would be perfectly possible to paint four or five pictures, each of which would be quite different in emphasis and rhythm, without departing at all from the facts given in the drawing.

Generally I find that I come away from a drawing session with a number of studies, some fairly complete and some mere notes, of each aspect that has interested me. The painting then becomes a matter of combining separate bits of information together. This is what happened in the painting of the orchestra with harps (Fig. 65). Figures 66 and 67 are two of several drawings which have been combined to make the final design.

The shapes of the instruments, and the stance and gesture of the performers, are so characteristic and inevitable that I would regard it as a confession of rank ignorance to make a mistake like getting the shape of a cello wrong, or putting a clarinettist's hands the wrong way round on his instrument—I have seen both howlers in otherwise realistic and respectable pictures. Continual observation, plus a very little knowledge, is the only way to get such things reasonably right. Even so, the difficulties of drawing violinists, for instance, are considerable, and don't seem to get any easier!

The shape of a stringed instrument is so beautiful in itself, and varies so subtly according to the angle at which it is held, that one can never take anything for granted. Trying to draw a string quartet, in which no less than four of these infernally difficult shapes are to be found, all held at different angles, and all moving, is possibly one of the most demanding subjects of all. None of the players is likely to be bowing in unison with the others, and seen from any angle the movement of the bowing arms and the direction of the bows makes a continuously changing pattern, crossing and overlapping each other and forming a variety of angles. These patterns do tend to repeat themselves, of course, and the draughtsman needs to develop that almost subconscious ability to seize the right moment and, so to speak, isolate it from the rest of the continuous movement. I think this is done, again without much conscious awareness of the process, by keeping one's eyes fixed on the moving subject until the instant that one wishes to 'fix', and then dropping them to the paper where the line or mark is put down. Then the process is repeated until one is able to catch the next fragment; it may be the fold at the elbow, the angle of the wrist, or the amount of cuff that is showing; or it may be a shape that recurs behind the arm that one is drawing—for everything, the background shapes as well as the foreground ones, must be seen together. It is of little use, when one comes to paint from

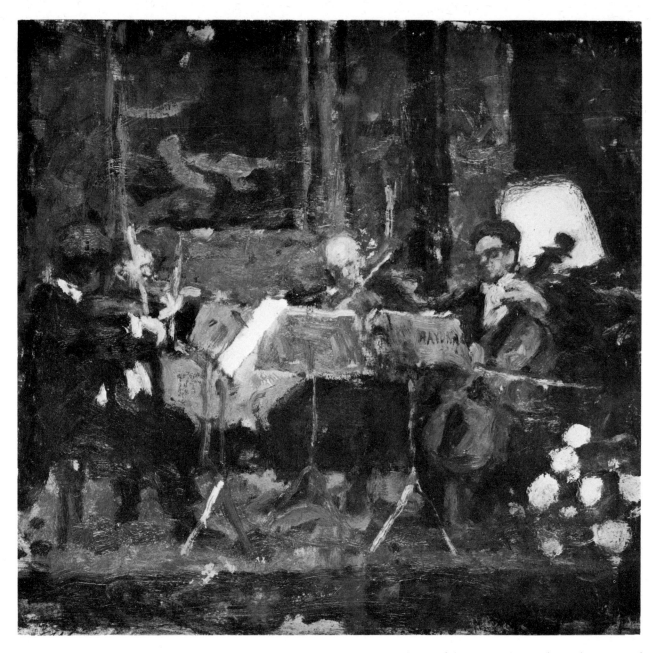

**Figure 68.** *The Amadeus Quartet.* 10 × 10 in. (Collection of Mr J. T. Burns.)
The Quartet was playing in a hall where the surroundings were rich and dark. The instruments and the music on the stands gleamed out from this mellow setting. The painting was done from several very small drawings and notes, which attempted to pack in as much information as unobtrusively as possible.

the drawing, to have a beautiful arm and no idea whatever of what is seen behind it.

Figure 68 shows the Amadeus Quartet playing at a concert in the Draper's Hall in London. I had already done several pictures of this quartet, partly because I greatly admire their playing, and also because their varied personal characteristics interest me. All string quartets are good to draw, of course, whether they are of this high standard or an amateur group; their gestures are so controlled, economical, yet expressive. However, some are better to draw than others, and the Amadeus all have particularly well differentiated visual personalities.

As is often the case with a string quartet, the first violin and the cellist seem to dominate by virtue of their nearness to the audience, while the two inner instruments—second violin and

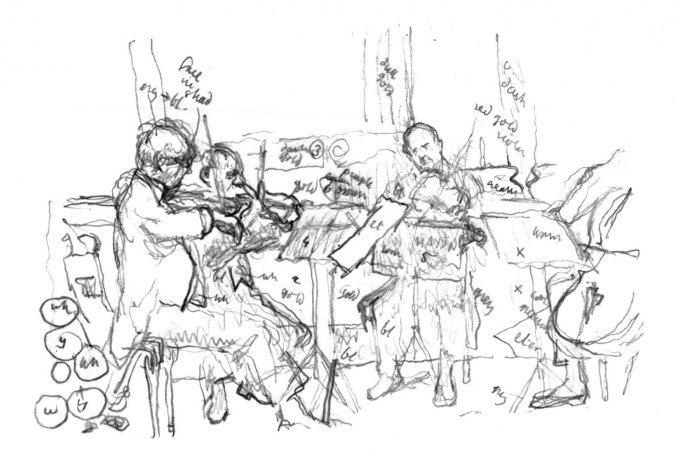

**Figure 69.** Working drawing for *The Amadeus Quartet.*

**Figure 70.** A method of noting tones, using numbers.

viola—are more self-effacing. This does not, of course apply to the musical sound, but to the visual or dramatic impression given by four very different individuals who make up a perfectly balanced whole. One of the reasons I never tire of drawing a quartet is that the size of the ensemble is large enough to give plenty of variety, while small enough for one to be very much aware of the individuals in it. But the number can also create certain difficulties. Four units, if spaced out equally, are awkward to design: they need to be grouped. So I often choose a seat to one side, as well as being close enough to the front to get a good view. With any luck—and usually one doesn't know what view one is going to get until the performance starts, unless it has been possible to get into a rehearsal—the first and second violins, or the cello and viola, will overlap and group themselves naturally, so as to give a varying distance between their heads.

A drawing made for this picture—I did two or three pages similar to this one during the concert—is shown in Fig. 69. The scale is very small, the whole of this page measuring only 5 × 7 in. When making these notes I always draw on as small a scale as I comfortably can. There are two reasons for this. One is speed. You can obviously get more done in the time if you haven't got large areas of paper to cover. The other, important in a chamber music concert, is silence. I mentioned above how important it is at a rehearsal to make oneself as inconspicuous as possible. At a concert it is equally important not to risk annoying other people in the audience. It is remarkable how much noise a

PAINTINGS IN PROGRESS

pencil can make, scribbling in an area of tone during a Mozart slow movement. So I use no shading, or else an absolute minimum, as you can see in this drawing. Instead, I make plenty of colour notes, with tones written in, and number a few of them. This is simply a form of shorthand which can be used more or less systematically. The range of tone in the subject is mentally analysed as running, perhaps, from (1), the lightest, to (6), the darkest, and corresponding numbers are written into the areas of tone in the drawing, instead of actual shading (Fig. 70). A sharp, soft (5B) pencil helps to cut down that insistent scratching noise.

The painting followed the drawing pretty closely. It was largely a problem of placing, selecting the format, and deciding where to put the shapes that the drawing provided. I often find, as I commented above when referring to the orchestra drawings, that if a drawing is complete enough to paint from it also gives me a distinct idea of the shape and final design of the picture.

The tone of this subject was on the dark side, so I used a panel prepared with rather a low tone, so that it was not too laborious to come down to the tone required. The part of the picture which

**Figure 71.** *Fidelio Overture* 8 × 7 in. approx.

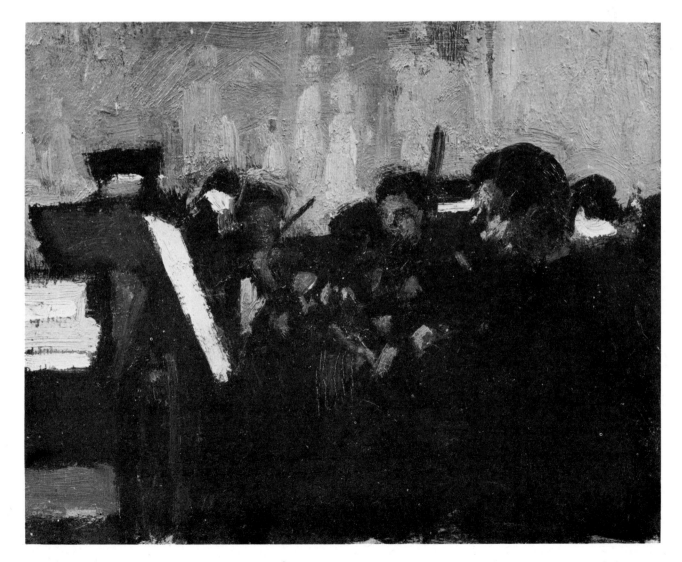

MUSICIANS

**Figure 72.** *The Rehearsal* 12 × 10 in. approx.

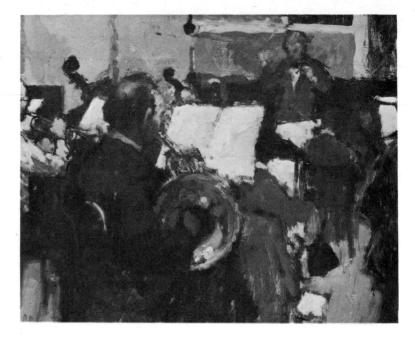

gave me most trouble was the head of the viola player, Peter Schidlof. In spite of the small size of the picture, I see no reason not to try for good likenesses of the people represented in it. I wanted the picture to be quite definitely the Amadeus and not any other quartet. Schidlof, for some reason, was very difficult to get right, and as his head could easily be covered by a postage stamp it was necessary to repaint the whole head each time. I must have done this six or eight times at least, scraping the paint right out every time in order to preserve a reasonably pleasant surface to work on.

I like to keep a fresh touch in these paintings, and this is not always easy when likeness, or other reasons, force one to retouch and repaint. Oil paint always looks best when put down as freshly as possible on a dry surface which is different in tone and colour. Putting the same colours down over and over again into wet paint, which becomes progressively thicker and stickier, can result in a very over-worked and tired appearance, although in the hands of a sensitive painter even this can develop its own particular beauty. But for most people it is probably better to scrape right down, and if necessary leave the area alone to dry. This is what I did, the painting being completed in three or four sittings. Most of the important decisions were taken in the first sitting and then a certain amount of fiddling took place, right up to the verge of beginning to lose the immediacy and freshness—the 'bloom'—of the paint. Knowing when this point is approaching, even if it hasn't already been reached, is something which only comes with experience; and this is a good thing, as I am sure it is necessary to learn by pushing paintings as far as one can, inevitably wrecking a large number of them. If the student was too cautious and left off his early paintings for fear of losing their freshness, he would endanger his later progress.

Plate 14 shows a larger chamber music group in action, playing

**Figure 73.** *Amadeus Quartet with Amaryllis Fleming* 10 × 12 in. approx.
This is a more complex composition, in which the heads of the audience fill the front of the picture. The cellist, with her striped skirt, adds an important area of pattern, while the only player to be seen clearly is the leader, who is almost in silhouette on the left. This is an example of a fairly confused scene which is not 'sorted out' at all in the composition; it is allowed to compose itself naturally, and even if some parts are difficult to 'read', they relate satisfactorily, in an abstract way, to the whole design.

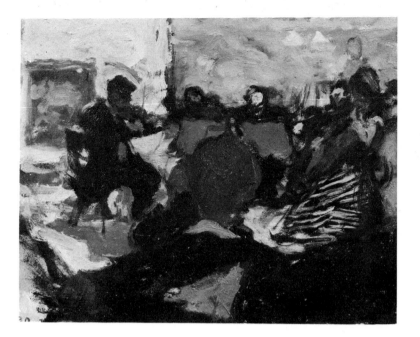

a Mozart serenade for wind instruments. Here there was the stimulus of drawing some very beautiful instruments that are not so common—the cor anglais, for instance, and the contra-bassoon. The latter stately instrument can be seen on the right. This ensemble offered a problem of design, as the players were strung out in a line across the stage. To avoid monotony, as much as possible was made of contrasts in silhouetting—a light head against dark, or a shadowed profile against the light—and the fairly close viewpoint, obtained by sitting right at the front, helped by producing a noticeable difference in scale between the figures in the foreground and the background.

At other times, whether from choice or necessity, I find myself a few rows further back, and use the heads of the audience in front of me as part of the design. An example of this, where the players recede until they become merely an element in the composition, is seen in Fig. 73.

# 8 Drawing

Most of the drawings reproduced in this book have been made for a particular painting, and often the painting has been done using the drawing as the main source of information. The drawing, in other words, has been a means to an end and not an end in itself. However, this is only one kind of drawing. In this chapter I would like to discuss not only the study which is done for painting but also the other motives for which drawings can be made—motives which lead inevitably to a slightly different approach.

This is one of those simple things which becomes more and more difficult and complex to explain the more we look at it. When I say that drawing is simple, I mean that it is the most direct and the most universal of all modes of visual expression, and the one which needs the least equipment. The draughtsman is fully equipped to produce his work, whether it be a masterpiece or merely a useful working note, a concise summing-up of movement in a few lines or a detailed analysis of complex forms, with no more than a piece of paper and a pencil—the same tools that are used every day by the milkman working out his bills or by a school child at his desk.

Yet the more one draws the more indefinable the whole business can seem. What is it that makes one drawing a superb masterpiece and another merely a competent description? How is it that a good draughtsman can suggest, with a couple of lines and a smudge or two, the mass and volume of a limb or a torso; and not only that, but the tension of its muscles, the hardness of bone and the softness of flesh? But really the most mysterious thing of all, as well as being the hardest to do, is the way that a simple outline—two lines, no more—can suggest roundness without the aid of any modelling or tone. Ingres and Picasso, to take two examples, can work this minor miracle over and over again. But such a summary statement can probably only be achieved after long experience of making drawings of all kinds, including many which have been pushed to a great degree of completion.

**Figure 74.** Quickly scribbled notes—sheep in an orchard.

golden corn

purple-red earth

sheep in orchard   10.9.72

This is an example of the drawing as a thing in itself, an art which is completely satisfying, both to do and to look at, and which can be done for its own sake, with no other end in view. But drawing can be used for many other purposes as well. It can be used simply as a means of storing information, and this is the way in which I have used it in perhaps the majority of examples reproduced in this book. Here the quality of the drawing does not matter so much as the amount it tells you about the subject— how much information it contains, to be wrung out of it when the time comes to paint. When I say that the 'quality' of the drawing does not matter so much, I should perhaps use some word like 'attractiveness' instead, for obviously the better the quality of the drawing the more useful and more vivid will be the information available. However, it doesn't need to be attractive; it can be written all over, smudged, erased and re-drawn.

A drawing can also be used in an exploratory way, as a means of analysis, to find out more about a subject. Before starting a painting many artists will make a number of preliminary drawings to find out about possible compositions, viewpoints, and so on. It is also often necessary simply to find out more about the subject itself, how it is put together and how it relates to other parts of the picture. A series of exploratory drawings of this kind can be seen in the chapter on painting a portrait.

One could perhaps include another category; the drawing done as rapidly as possible as a note for future reference, simply to fix a possibility in the mind, or to remind oneself later of something that there has not been time to consider properly. I find that I am continually making such notes of, for instance, fortuitous poses which appeal to me. Sometimes I come across the drawing later on and find it suggests something useful to me. Such scribbles, of which Figs. 74, 75 and 76 are examples, are put down rapidly on any scrap of paper that may come to hand, for example the edge of a newspaper, or the back of a letter. If you are of a tidy or hoarding disposition it is a great help to have a special folder or

**Figure 75.** Quickly scribbled notes—woman holding a cup.

drawer into which such notes can be thrown, or, even better, a large notebook to stick them into. For some years I have followed this practise, and the resulting scrap books turn out to be full of interest and possible ideas when one goes through them later (Fig. 77).

So there are many possible motives for making a drawing. It can be regarded as a complete work of art in itself, or as a mere vehicle for information, as practical and prosaic as a laundry list. It can be a keen and precise instrument for the analysis of form and shape, or a way of working out a design, or a rapid memorandum of something which might otherwise be forgotten.

In my own case the different motives definitely help one another. As an art student I was encouraged to think that to draw well was about the most important thing in the world, and our

**Figure 76.** Quickly scribbled notes—nude.

PAINTINGS IN PROGRESS

Figure 77. Two scrapbooks full of drawings on scraps of paper.

energies were largely devoted to trying to attain this elusive end. For my own part I developed something of an inferiority complex as a result of this tremendous emphasis on drawing for its own sake. There always seemed to be fellow students who could produce admirable drawings—or what seemed admirable to me— with ease and precision. It was not till I started painting seriously and found it necessary to make studies for my paintings that my drawing began to look up. At last I was able to put things down on paper with a relative lack of self-consciousness, because the result was, after all, only a 'study'. The effort made to collect plenty of information turned out to be the best possible way of achieving some sort of intensity in the resulting drawing, whereas if one is thinking—as many art students do, or did—too much about what the result will look like and how it compares with Ingres, John or Raphael, the finished drawing is so often disappointingly empty and purposeless.

At the same time I am extremely glad that I spent so long a time in the life room, simply trying to draw the figure adequately. It gave me, I think, a lifelong love for figure drawing for its own sake, so that now at regular intervals I have a model and spend an afternoon doing drawings. Figures 78–80 and 87 are typical products of this enjoyment of drawing for its own sake.

Perhaps this is the moment to put down a few remarks about life drawing as a subject for the student. I am old-fashioned enough to think that art schools made a great mistake when they banished the life class from its position as the basic discipline for the art student, reducing it merely to an occasional activity. No doubt there had been too much emphasis placed on drawing the nude model, and it had been allowed to become too much of a routine. After all there are plenty of other natural forms, animal, mineral, and vegetable, which should also be studied, not to mention clothed people seen in their natural surroundings. An ideal curriculum would include all these subjects; nevertheless, the nude human body can legitimately be thought of as the most difficult and most rewarding of all. It contains the greatest possible

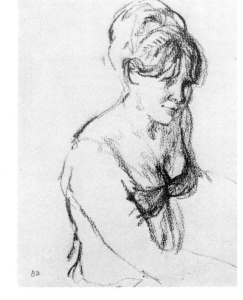

Figure 78. Girl in bra (charcoal).

**Figure 79.** Nude lying (charcoal).

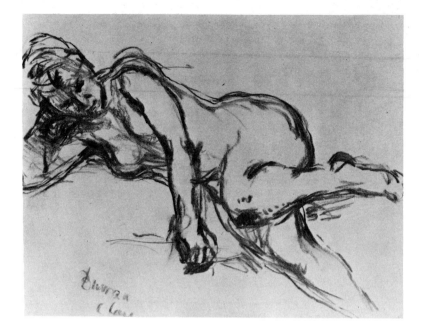

**Figure 80.** Nude with hands clasped (brown chalk).
This is a life drawing done purely for its own sake. The drawing took only ten minutes or so and was done during a session with the model which resulted in perhaps a dozen similar drawings. This particular one, like many of my figure drawings, was done with a fairly soft brown chalk in pencil form—a convenient compromise between the extremes of a sharp pencil and a soft, easily smudged piece of charcoal. At different times, however, I enjoy using any of these methods.

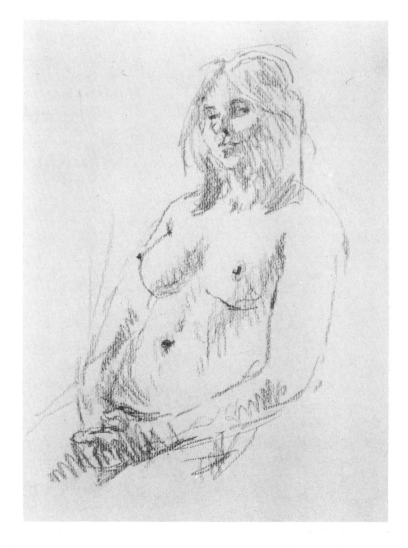

**Figure 81.** Baby standing (charcoal).

subtlety of line and variety of movement, and such continuously varying contrasts between hard and soft, angular and rounded, tense and relaxed forms. Also, above all this, there is the humanistic value of such a subject: 'The proper study of mankind is man'.

In a society which so often disregards human scale, human rhythms and needs, which so often gives the impression of regarding machines as really more admirable (so that a good boxer, for instance, will be described in a newspaper as 'a magnificent fighting machine'), it is a very good thing that students should have to concentrate for long periods on the study of the human body, which besides being the most perfect and complex structure known to us, is also the most intimately familiar—because it *is* us. And it is also a good thing for young students to be faced with the variety of different models—old, young, fat, tall, handsome, ugly—which a regular life class will provide them with. There is something democratic about the life class. One week they will have a superb, vigorous young model to draw, the next perhaps an aging woman past her prime. Each has to be looked at with the same care and respect and, one hopes, sympathy. (The quality of the teaching is, of course, all-important here.) In spite of the many shortcomings of the old art school system, the student did have, through the life class, a direct contact with humanity from the outside world, humanity of many different shapes and sizes stripped to its essentials, with nothing disguised or dehumanized. We didn't always have the models we should have liked to draw, but if we were working seriously we had to look at them all equally. The modern student, with his abstract exercises and projects, and, unhappily, his tendency to use photography as a substitute for looking, has no such humanistic basis for his study, and to me seems the poorer for it.

As I have said, the old life room curriculum was too limited. If one is studying such a magnificently organized structure as the human body, then it should be considered in greater depth. Anatomy should surely be a serious topic, not merely a routine. The figure should be studied in action, in relation to its surroundings, in as many different ways as possible without becoming superficial. This is a digression, but not a pointless one, as I believe figure drawing to be an essential, basic discipline as well as a joy.

One of the main differences between the drawing done for its own sake and the study for a painting (see Figs. 80 and 83) is that the latter very often relates objects to its surroundings and looks at everything with approximately equal emphasis, whereas the drawing which is not done with this purpose can isolate its subject. It seems quite reasonable to draw a figure totally on its own, in an expanse of white paper, not even indicating the floor or a shadow cast on it; we take it as a perfectly natural thing. Suppose we used the drawing to paint from, though, we should very quickly be in difficulties; we hardly ever see people against a neutral void, and every part of the contour is likely to be modified by what it comes up against.

**Figure 82.** Studies for a composition (charcoal).

Degas was able to draw his figures in the classic fashion, without indicating any background or surroundings, and to use them as studies for his paintings. This is, in fact, the traditional method of building up a picture from separate studies of figures and surroundings, and suits pictures which are rather linear in character. When greater contrasts of tone are used, as for instance in the work of Rembrandt or Millet, you usually find some indication at least in the drawing of the figure's environment. Often it is constructed and explained very fully. In more recent times this relating of a figure with its surroundings in a drawing has been developed into a new, and largely English, tradition, the greatest exponents being Whistler and Sickert, and the other painters of the Camden Town Group. A whole generation of English painters, trained before or after the last war and up to about 1955, based their drawing on this tradition. In drawing the contour of a leg, for instance, they would interrupt the line to indicate the precise

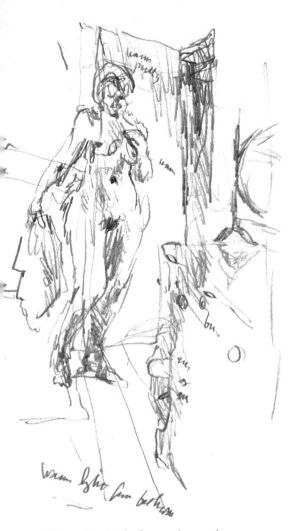

**Figure 83.** Study for standing nude.

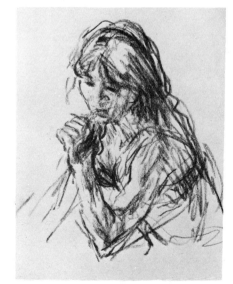

**Figure 84.** Girl with hand at mouth (charcoal).

**Figure 85.** Girl leaning head on hand (charcoal).

point at which a shape, such as the skirting of the wall behind, cut against it.

A drawing for a painting in the hands of an artist like Gilman, who worked from drawings in the most methodical way, became something like a map, which endeavoured to indicate as clearly as possible the shape of every patch of colour that would make up the design. Sometimes this complex patchwork can be taken further with indications of tone, whether shaded or numbered, and colour notes written in. Theoretically it should be possible to pack a drawing like this with so much information that someone else who had no knowledge of the original subject would be able to take it up and make a 'readable' painting from it. Of course this is an extreme example, and very few painters would want to put so much into a drawing. There might very well be, in fact, a danger of exhausting the impetus on the preliminary stages and not having enough steam left for the actual painting.

Still, this tradition, very much reduced and simplified, is at the back of studies like Fig. 104 and 83. Of course one is using memory to a considerable extent, and also what capacity one has for invention, a creative modification of the facts in front of one. So often the drawing will concentrate on those aspects which would be difficult to remember or invent. Thus, Fig. 53 is largely about tonal relations and the way the figure links up with the background, while Fig. 38 deals primarily with the placing of dark shapes and accents.

The other illustrations to this chapter are either self-explanatory or can be commented on most conveniently in the captions.

A note about materials. Charcoal or soft chalk is an irresistible medium for doing figure drawings like Fig. 79 or 84 or for exploratory studies (Fig. 88) in which whole areas can be easily

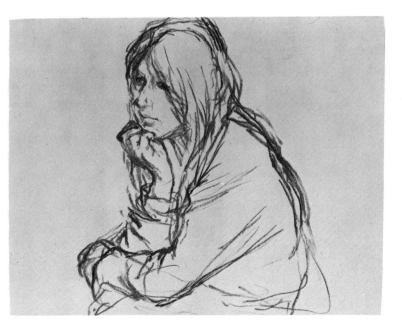

**Figure 86.** Wendy (charcoal).

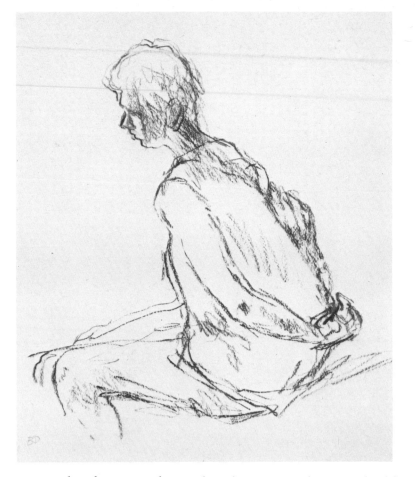

**Figure 87.** Standing nude.
The model took up this standing pose quite naturally. We had just finished a drawing and she stood by the radiator to get warm. A good model, I sometimes think is simply one who moves quite naturally and unconsciously from one drawable pose or action to another. Degas, of course, always loved the natural, often slightly awkward movements best, and regarded them as more truly graceful than classical poses. The trouble is that they often can't be held for more than a few minutes. This drawing was made as quickly as possible with a soft pencil, as the model found it difficult to hold the pose for very long.

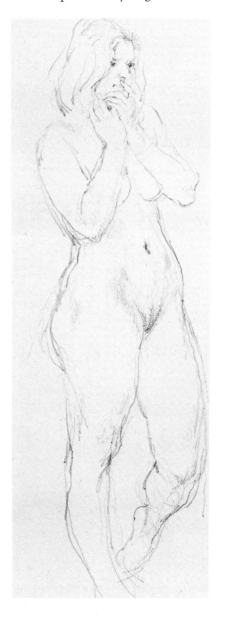

removed and contours lost and re-drawn. It is the most flexible of media and lends itself equally to a pure line (Fig. 84) or great depth of tone (Fig. 85). However, for working drawings or sketchbook notes, which are generally on a small scale, greater precision is called for, and nothing can beat an ordinary lead pencil on smooth white paper. The pencil, too, is very versatile, and it is particularly useful to be able to indicate, with greater ease than in any other medium, the precise difference between a definite accented edge and a slightly 'lost' one (Fig. 87).

I have mentioned sketchbooks already, in Chapter 5. Personally I like a properly bound book and not one with spiral or loose leaf binding. These sometimes allow the pages to move sideways a little, and the result of this on a drawing done in a soft pencil or chalk can be a disastrous rubbing.

There is no virtue, either, in using materials unsympathetic to oneself. Obviously a Rembrandt or a Turner can make almost any material do what he wants. Lesser draughtsmen are entitled to choose their materials carefully for their sympathetic touch. (It is probably true, also, to say that in Rembrandt's day, paper was in general a good deal more attractive to work on than ours). If you tend, as I do, to draw scratchily and clumsily on the wrong sort of paper or with too hard a pencil, then don't go on struggling but get back as quickly as you can to more attractive materials.

PAINTINGS IN PROGRESS

**Figure 88.** Composition studies, the bathroom (charcoal).

These composition studies were made without the model, while thinking about a possible picture using two figures in a bathroom. Charcoal is an ideal medium for 'thinking on paper', as it can be rubbed out and smudged with the finger in an instant, almost without stopping the process of drawing.

# 9 Bathroom pictures

Different rooms in a house can be related to various kinds of painting. The kitchen is the source of all the finest still-lifes. The textures and forms of pots, pans, vegetables, bread, and fruit that are found here have always provided an inexhaustible source of subject matter for the painter. The sitting room and the bedroom are the settings for figure paintings; conversation pieces, portraits and genre pictures of all kinds have their beginnings here. They form the background to figures talking, drinking, making love, dressing or undressing. Finally the bathroom, a comparative newcomer, provides the painter with his excuse for catching the nude figure, as if unawares, in natural movements and situations. It is this essential naturalness which distinguishes the bathroom setting. In the drawing-room or the studio an arranged pose may be perfectly suitable, but in the bathroom it would look absurd.

Up to fairly recently—recently, that is, in the history of art— the bathroom did not exist as a separate room, and washing was carried out in a tub in the bedroom, as we can see in innumerable pastels and drawings by Degas. He used to keep a tin bath at hand in his studio so that he could draw his models washing and drying themselves. The first great painter to use the actual bathroom itself as the setting for many of his finest compositions was Bonnard, whose wife, fortunately for us, had a passion for washing herself. There was always a well-equipped bathroom in the Bonnard home.

A bathroom is normally a small space, and obviously there is not likely to be room to set up an easel or a large canvas and still keep the essential spontaneity and 'unposed' quality of such subjects. So obviously this is another of those situations in which drawings and studies must be accumulated. Fortunately the occasion for making studies is repeated over and over again, with little variation, and it is easy to refer again to the model for a new note of some detail or incident—the bend of an arm, or the way the light falls on a towel.

**Figure 89.** *The Bathroom Mirror* 20 × 16 in.

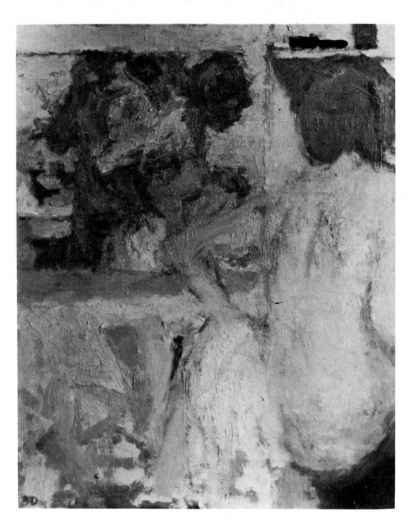

Over a period of some years I have found the subject of a bathroom scene sufficiently engrossing to do a series of fairly large pictures, in which I have moved from a single figure, washing and drying herself, to attempts at combining more than one figure to make a more complex composition. People do share a bathroom, after all, particularly nowadays!

On adding up my list I find, a little to my own surprise, that it totals at least eight pictures. Some of these have been among the largest and most ambitious pictures that I have ever done. I think perhaps the best thing I can do is to go through a few pictures chronologically, making what comments I can.

The first three pictures are comparatively early. Fig. 89 used the reflections in a bathroom cupboard mirror. I was particularly interested in the big difference of scale these make when compared with the figure in the extreme foreground. The extremely cramped conditions meant that I was having to draw much closer up to the figure than one would normally do. Her back and shoulder were probably not more than 18 in. away from me, while the mirror was about 3 ft 6 in. away. Obviously a certain amount of adjustment is necessary to avoid odd distortions, both while doing the studies and later in working from them, but I find personally that

BATHROOM PICTURES

**Figure 90.** *The Shower* 50 × 42 in.
This is a large painting, worked at over a
long period of time and using many
drawings and studies. As the composition
developed, it began to fall naturally into
three stripes: the comparatively empty
large stripe on the left, then the figure, and
on the right hand a narrow but complicated
stripe which, though it may look almost
like an abstract pattern, is made up entirely
of the actual, observed shapes of slippers,
clothes thrown over a chair, and so on.

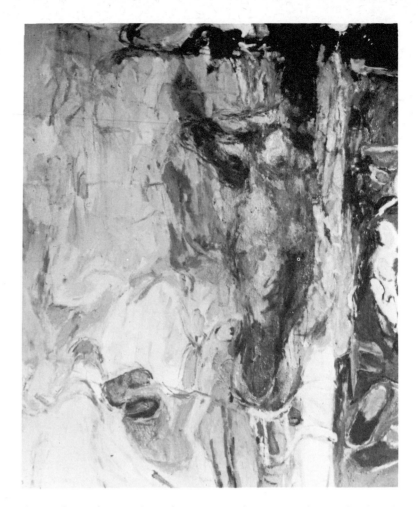

the awkwardness of working very close is made up for by the
fascination of the problem involved. Often several viewpoints
have to be combined. I will have more to say about this problem
when I come to later pictures in this series.

The colour of this first picture is pearly and light, and depends
very much on the attractive chord of pink, silvery grey, white and
cream, with a few dark accents. In contrast Plate 15, is, to my
mind, overstated in colour. It belongs to a period when I did
some large paintings in which the intensity of colour was pitched
much higher. Some earlier large compositions had become so
overworked and dingy in colour that I had almost given up
working on a scale larger than 25 × 30 in. On beginning again,
I found that it helped enormously to do a few pictures, like this
one and the one following it, in which I allowed myself to be
much more free with both colour and form. However, I came to
the conclusion that this was not a natural path for me to take.
There was someting forced about these pictures. It was a transi-
tional stage, but a valuable and necessary one because it enabled
me to break through the inhibitions which had built themselves
up around the bigger scale.

It is worth mentioning this because it may help to show that
there is nothing intrinsically 'better' or even inevitable about a
change of style in the direction of increased freedom. It can turn

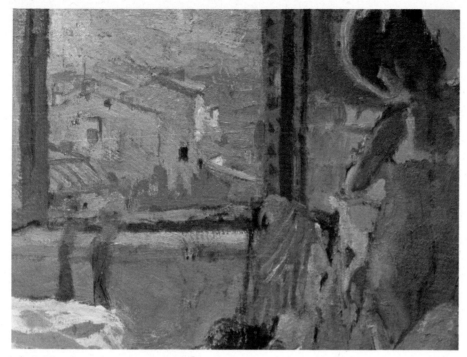

**Plate 13.** *San Gimignano* 10 × 13 in.

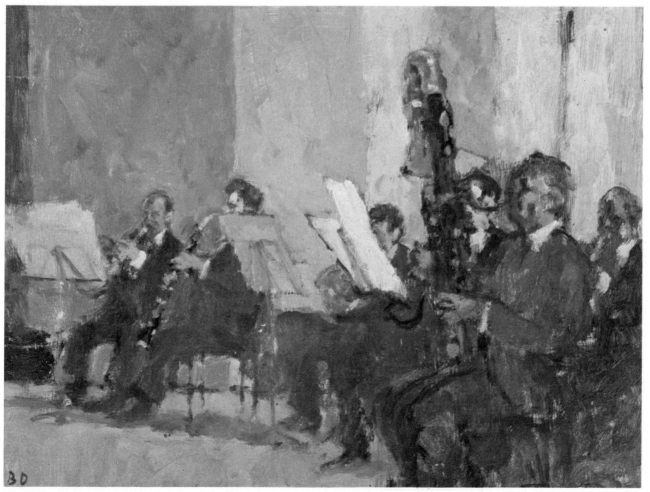

**Plate 14.** *Mozart Wind Serenade at St John's, Smith Square* 9 × 11½ in.

**Plate 15.** *Two Girls in a Bathroom.* Oil on canvas 50 × 40 in.

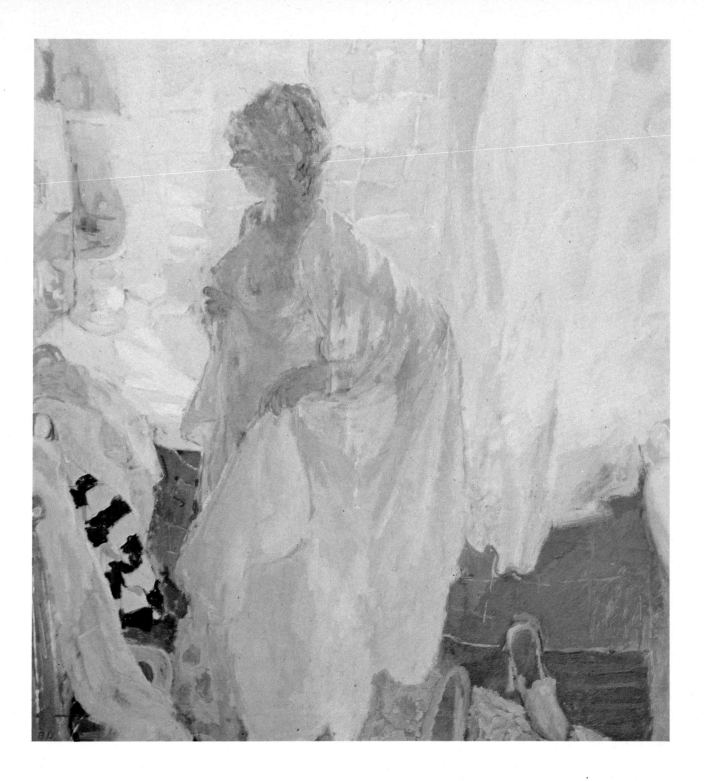

**Plate 16.** *Nude in Yellow Bathroom.* Oil on canvas 46 × 42 in. The sunlight comes into the bathroom for a short time during the morning in summer. It falls on the white bath, making patches of brilliant but soft reflected light on the figure. Her head is illuminated in this way from below.

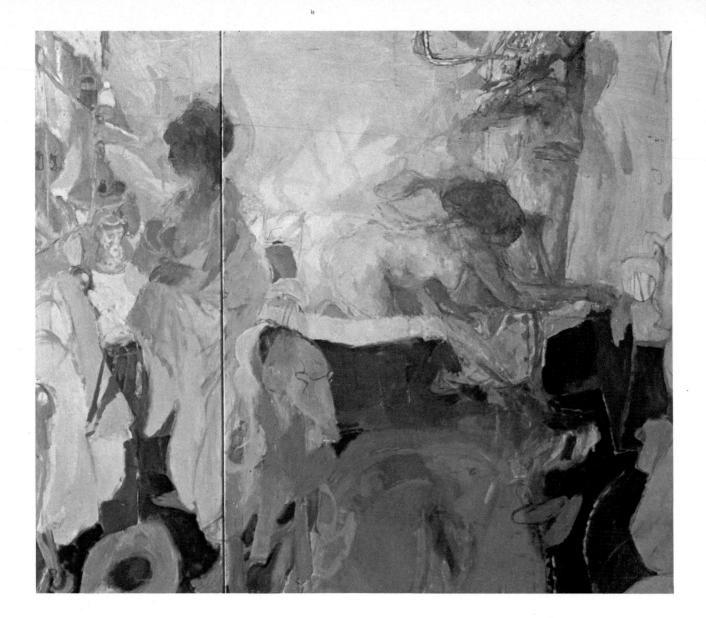

**Plate 17.** *The Bathroom.* Diptych 60 × 72 in. This large painting developed into a diptych—
a picture on two separate canvases—by a natural process. The larger part on the right was
painted first. One day in the studio it happened to be stacked next to another canvas containing
a standing figure; the two seemed to fit together, so the next stage was to add a thin, narrow
canvas—the two stretchers are simply screwed together—and introduce a new standing figure.
The whole picture was then repainted. The handling is kept flatter and more decorative than
it is in the other examples.

    A bathroom is full of useful material such as towels, mats, clothes, the shower attachment,
even a weighing machine, and all contribute their share to the whole pattern.

out to be merely a stage in one's development, or a necessary experiment from which one can return, as in my case, to something more satisfying and natural.

The picture in Plate 15 was frankly experimental. It was built up from two separate studies of the nude figure, one in the bath and the other standing.

Figure 90, *The Shower*, has an element of the freedom of the last painting about it but as far as I am concerned it is far more successful; in fact it is rather a favourite of mine. It is possibly based on more studies than any other painting I have ever done. For quite a period I used to make drawings regularly of my wife using the shower, and the painting would change almost as often as a new drawing seemed to suggest a slight improvement or a minor adjustment, and sometimes a major one. I must confess that this painting has cracked badly, and this did not happen because of the frequent repaintings. The ground was to blame, and the cracking was so bad down the left hand side of the canvas that in despair I started sticking strips of new canvas over the worst areas, forming something like a collage of canvas. The cracking

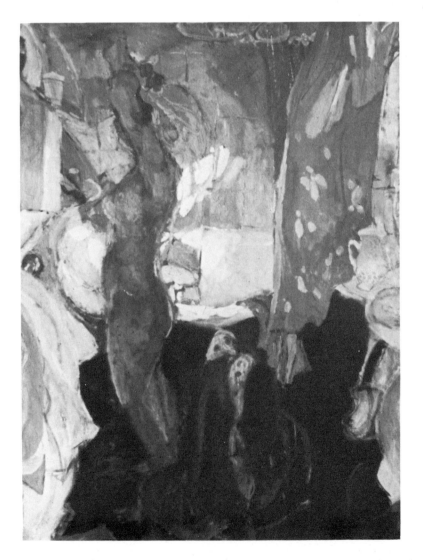

**Figure 91.** *Nude standing in a Bathroom* 60 × 48 in. (oil on canvas).

BATHROOM PICTURES

has not continued or got any worse, and I have come to accept the rather odd appearance of the picture.

Figure 91 and Plate 16 show a return to an apparently more straightforward interpretation—as far as handling and tone are concerned, that is. However, there are quite a lot of things going on here that are not altogether straightforward. The viewpoint is very close to the model in Fig. 91 and yet her legs and feet are firmly in the picture. This has meant a combination of at least two viewpoints, one looking straight at her head and torso, and the other looking downwards to her feet. In practise this is not quite so much of a problem and one seems to accept it almost unconsciously while making the preliminary drawings. The colour in these two pictures is not forced but even so it is a good deal more varied and inventive than is my usual practice in a small picture, and the forms are kept rather flat, almost unmodelled, producing a more decorative effect. If you compare Fig. 91, which is nearly 5 feet high, with, say, Fig. 97a, which is a small panel of less than 12 in. high, you will see clearly the difference of handling. I find that this combination of greater scale with flatter shapes and more inventive colour seems to happen quite naturally. I have no particular explanation of it, and in fact it would be just as logical the other way round—flat pattern in the small picture and realistic light and shade in the big ones. But it doesn't happen like that—not to me, at any rate.

A second version of this picture was much narrower, making a long thin shape 60 × 20 in. It interested me to work this out, as it is a format I don't very often use. The action of lifting a nightdress over the head was the starting point of both these pictures. A series of related drawings is shown in Fig. 92.

In the summer there is a short period in the morning when the sun is able to come into the bathroom. A patch of sunlight shines directly on to the bath, but as it moves around the sun disappears behind a roof and this short-lived illumination fades. But while it lasts, the whole room is completely transformed. There is now a strong illumination reflected upwards, bouncing off the pure white of the bath, and it gives a particularly glowing and tender light to the figure.

This was the starting-off point for a burst of drawing and painting; innumerable studies were followed by several large canvases. The light is probably in exactly the right place for only ten minutes or so at a time, and therefore studies have to be made at top speed. When you consider that not every possible free morning is a sunny one, you can see that gathering material for these pictures was sometimes a frustrating process and always a hurried one. However, a certain pressure on the artist is no bad thing in my opinion. If he has five minutes to put down essential information he has to go straight to the point, and something of this urgency may come out in the painting.

Two of the pictures using this reflected light, with straightforward compositions of single figures, have already been discussed (Fig. 91 and Plate 16). The light reflects upwards from the

**Figure 92.** A group of fourteen drawings used for bathroom compositions.
All these drawings have been used at some time or other in the development of a picture. Some are ideas for the whole composition, while others work out some small part, such as the way the towels hang over a rack, or make a careful notation of colour and the way the light falls.
One gets into the habit, when making these quick notes, of putting down, as far as possible, what one needs, and leaving out inessentials. Every painter who works from drawings develops his own shorthand. 'blu.', 'viol.', 'lt.', 'dk.', 'wh.' are self-explanatory as colour notes, but I also find it very useful to note the direction of the light, or a place where the edge of a form is soft or sharp.
When painting from a drawing it can be very frustrating to find that your study gives you plenty of information about, say, the figure, but leaves you totally in the dark as to the surroundings. Does she come against a shadow area—if so, is it lighter or darker than, say, the dark side of her arm? These relationships, as well as the more obvious ones, have to be noted as far as possible in the drawing.

PAINTINGS IN PROGRESS

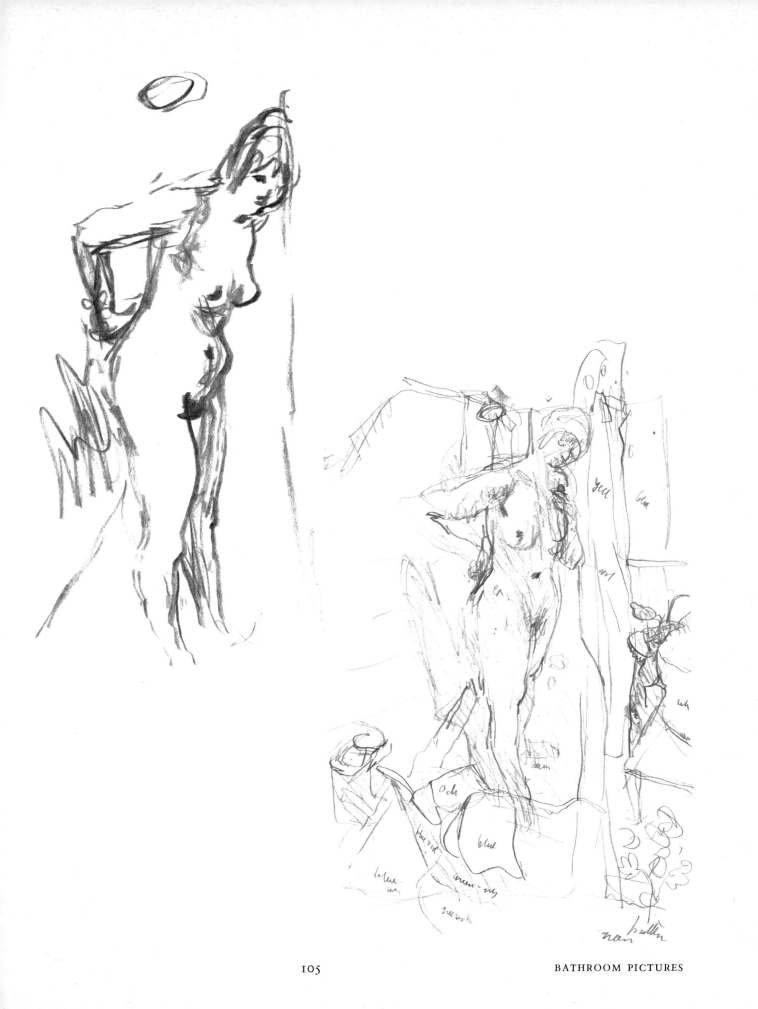

BATHROOM PICTURES

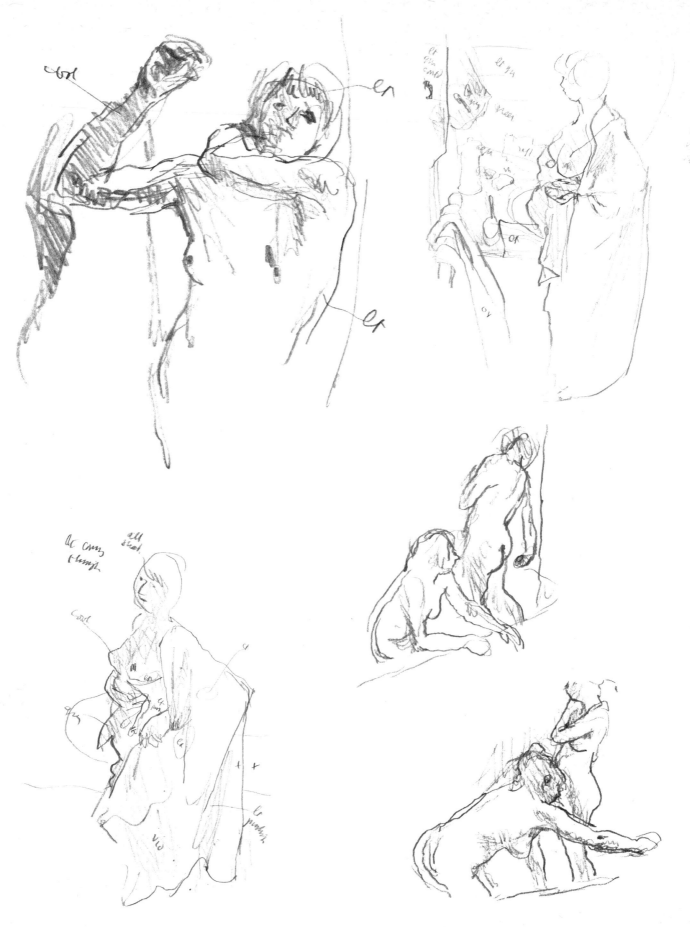

106

white bath so that the figure, mostly in semi-silhouette against the light walls, is also lit warmly from below.

The last two pictures Fig. 92 are the most ambitious. As I mentioned earlier, I attempted here to combine several figures. Mostly they are pieced together from individual drawings, but I was also able to pose two models together for some drawings. Some of the studies, like this one, were, of course, done simply to arrive at the pose and movement of the figures and took no account of the lighting conditions. Other studies concentrated on this aspect. At one point I even found it helpful to try the time-honoured device of making little models in clay of the figures (Fig. 93) and moving them around in a suitable light.

Figure 94, *Sunny Bathroom*, is a large canvas with three figures; one is standing in the shower, while her companions are sitting on the edge of the bath and at the other side of the bathroom. Their arms form a linking rhythm, and the pattern of shapes throughout the picture is very varied and complicated. The picture is, I'm afraid, difficult to 'read' in a black and white photograph, but perhaps the composition notes (Figs. 95a and b) will help to clarify the design.

The viewpoint would be called by a photographer a 'wide-angle' one. The actual room is tiny, measuring only just over $8 \times 6$ feet. I have done a little diagram of the room (Figs. 96a and b) with the figures in their places represented by the letters A, B and C. It is easy to see that a spectator viewing the scene from the position X would have to use at least three separate viewpoints, for he would be taking in an angle of vision of something like 160°. Generally it is considered that for normal

**Figure 93.** Two clay figures used as an aid in working out compositions.

BATHROOM PICTURES

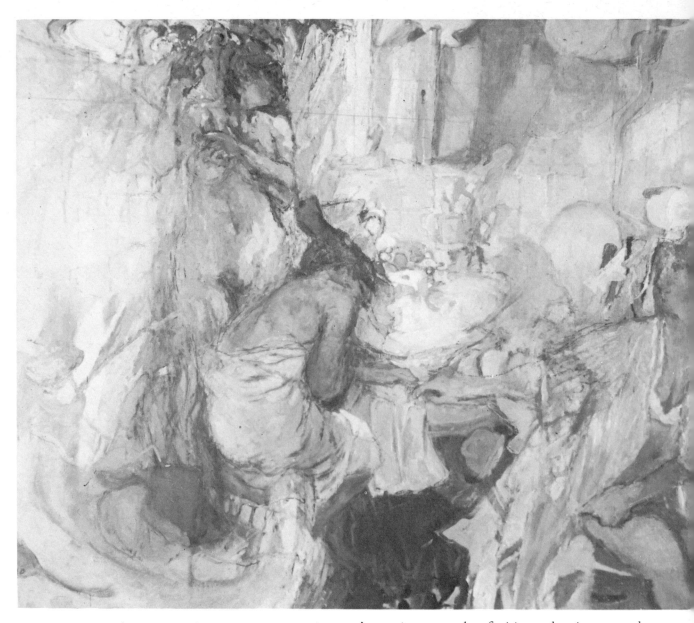

**Figure 94.** *Sunny Bathroom* 60 × 48 in.

perspective one's maximum angle of vision—that is to say the extent from one side of the field of view to the other—is about 60°.

The effect is a little as if the two outer side walls of the room had been opened outwards, as indicated in my second diagram (Fig. 96b). The whole thing, of course, depends on a series of compromises. A balance has to be found between the demands of a realistic representation and those of the design on the flat picture surface; between the distortions that have to be assimilated, and the 'readability' of the final result. What makes it rather difficult to write about is precisely that these balances are arrived at in an altogether intuitive way. The picture is right when it looks right.

The last, and biggest, of these pictures is shown in Plate 17. It is in two parts, forming a 'diptych'. The squarish main part is flanked by a thinner strip at the side, though the design in continuous. This, like Topsy, 'just growed'. The square canvas was

**Figures 95a and b.** Two composition studies for *Sunny Bathroom* (pencil).

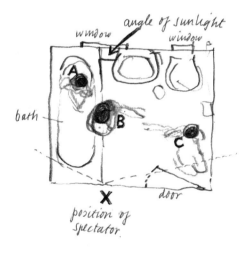

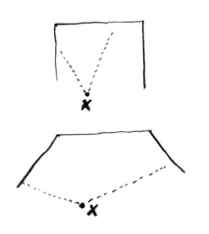

**Figure 96a and b.** Diagram showing plan view of the bathroom with the three figures placed as in the painting.

tackled first and developed as a self-contained entity until one day I caught sight of it in the studio leaning up against another canvas, the tall thin version (Fig. 91) that I have already mentioned. The two seemed to fit together naturally, and this gave me the idea of adding two side panels, forming a triptych. I was going to have the standing figure in the left-hand panel, and keep the right-hand one relatively empty. However, it seemed to work perfectly well with only one side in place, and I eventually scrapped the idea of a right-hand panel. The standing figure is related both to Fig. 91 and Plate 16. The treatment is flatter, less 'baroque', than the *Sunny Bathroom* with its swirling movements.

Finally, back to a small picture using only a single figure. Fig. 97a is another study of the shower in which the actual quality of the light and the way it falls has been analysed more closely.

**Figures 97a, b and c.** *The Shower*
13 × 11 in. The painting in three stages.
Unlike the big picture of the same subject
this smaller version, painted some time later,
developed in a straightforward and fairly
rapid way. It is also a good deal more
naturalistic in style, as is often the case
when I do small and large versions of the
same subject. The way in which the sunlight
comes in through the window, touches the
shoulder and head of the figure, and is then
reflected back from the bath, illuminating
her from below, is the real motive behind
the painting.

I have included a couple of earlier stages (Figs 97b and c) of this picture for good measure. You can see how it has developed fairly directly from a first brush drawing on the panel, not much more than a positioning of the main elements in the design, to a tonal stage without strong accents or contrasts, and then a final state in which the drawing is sharpened and tonal masses are built up. This development is as near as I can achieve to a logical process, and contrasts considerably with the trial and error, the empirical procedure, that is typical of the large compositions. However I am convinced that both approaches have their own validity; and, in fact, that they help each other.

# 10 Auction rooms and Art galleries

I suppose there must be something in common in all a painter's favourite subjects; some theme which runs through them all. In making a list of the chapters for this book, subjects that I return to again and again, I found that I had spent some time making drawings and studies of interiors in auction rooms and galleries, which had resulted in a number of paintings of these subjects. Both are interiors in which a number of people come together for a common object. As this object is to do with pictures, I am familiar with both *milieux*. This familiarity, it will have been observed by now, is a necessity for me. I must feel at home with my subject matter, it has to be a part of my own experience, before I can think of painting it.

Both auction rooms and picture galleries have in common, also, a certain quality of light which you only find in rooms with top lighting; and in both, as in the musical subjects, the figures move purposefully but reasonably slowly, and are continually taking up one characteristic attitude after another. They offer admirable opportunities for casual groupings. Finally, in both the big London auction rooms of Christie's and Sotheby's, there is very interesting colour—particularly in the former, with its walls of a subtle but powerful green.

Most auction rooms consist of several galleries opening off each other, where the pictures and other items are displayed before the sale, the auctions themselves taking place in the largest room. This set-up gives scope for the compositional device of looking through one room into another, which all artists interested in painting interiors have used at one time or another. I always find this kind of composition interesting to tackle, as the doorway 'frames' the further room, and a contrast is set up between the different lighting and colour. Compositionally then, this type of subject often links up with quite a different sort of interior, i.e. the bathroom pictures shown previously.

Both the pictures of Christie's show this viewpoint. I saw the first one during the viewing for a sale which contained some fine

**Figure 98.** Sketchbook note of a painting by Vuillard.
This is an example of the kind of note that I find it useful to make in galleries and exhibitions. It is merely a memorandum of a picture that interested me; but I am sure that the act of making even such a hasty drawing helps to fix the picture in one's memory. This particular note, of a painting by Vuillard, was made a few minutes before Fig. 99.

**Figure 99.** Drawing done at Christie's.

**Figure 101.** *A Vuillard at Christie's*
12 × 9½ in. approx. (Collection of Admiral
Sir Deric Holland-Martin.)

**Figure 100.** Drawing done at Christie's.
This picture of figures seen a doorway is a
follow-up to Fig. 99. The yellow sofa,
with its beautiful curved back, caught my
eye as two figures moved away from it.
The strong black silhouettes behind it seemed
worth noting too, and I have written down
that the lightest accent in the scene was the
white notice on the wall. So there are
altogether three facts stored up in this
scribble.

Impressionist and modern pictures, including a large painting
by Vuillard of two people talking on the edge of a tennis court.
This painting was by no means one of his masterpieces, but as I
find any picture by Vuillard interesting I spent some time in
looking at it and making a small pencil drawing (Fig. 98). In
passing I might add that I always make some memorandum, even
if it is only the slightest of scribbles on the back of a letter, or in
the margin of a newspaper, whenever I come across a picture
which takes my eye. It is a useful habit, as it definitely helps to fix
a picture in the memory.

After making this drawing I went to look at something in
another room and, happening to look back at the Vuillard,
noticed this composition seen through the doorway. Having my
sketchbook still in my hand, I made a couple of little drawings
straight away (Figs. 99 and 100). What interested me especially

PAINTINGS IN PROGRESS

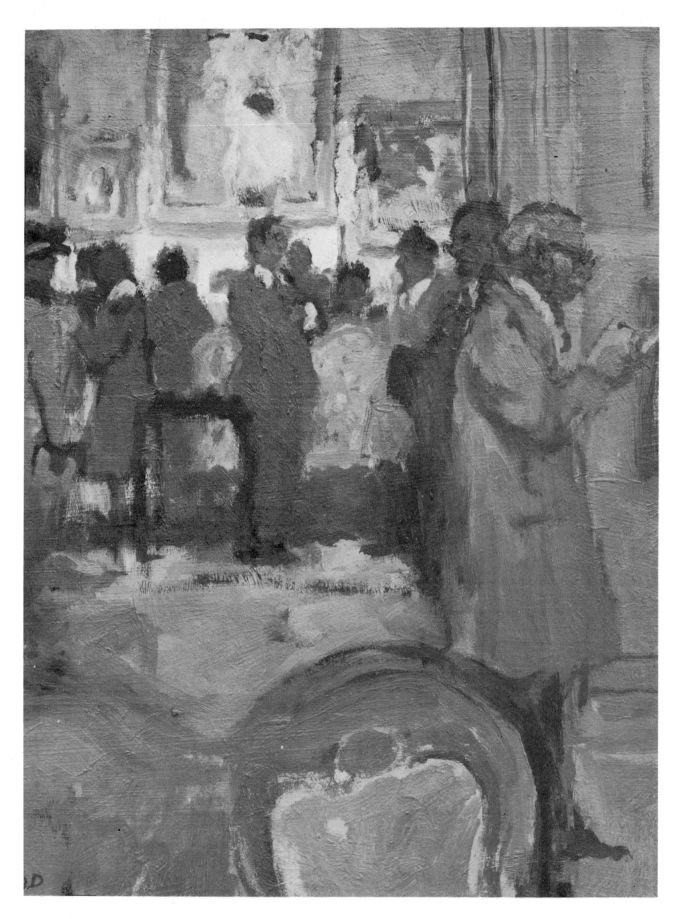

AUCTION ROOMS AND ART GALLERIES

**Figure 102.** Drawing done at Christie's.

was the contrast in tone and colour between the brightly lit far room, with its strong blues and golds, and the comparatively subdued colour in the foreground. The general colour chord is made up of a grey-blue or grey-green and a biscuit or honey colour. Against this, the figures tell as sharp dark and light silhouettes.

The painting proceeded in two jumps from this single drawing. The first stage consisted of putting down the main areas of colour and developing the setting of the interior, with the pictures and so on, fairly completely, but leaving the figures rather vague. The panel was then put away while I got on with other pictures, and was not taken up again until several months later. The figures were then completely repainted. The man in the foreground was introduced and painted from the imagination—or partial memory; I feel that he bears a strong resemblance to someone I may have seen at an auction. This figure, larger than anyone else in the picture but very low in tone, had a useful effect in helping to frame the bright figures and the picture in the far room (Fig. 101).

Some time after this, I was in Christie's again and noticed a group of people bending over some glass cases. I have forgotten what it was that they were so interested in, but at the time I made a few hurried drawings (Fig. 102) and later I was able to go back and make some more notes. In some respects both these little pictures of Christie's are similar; they both use an upright format

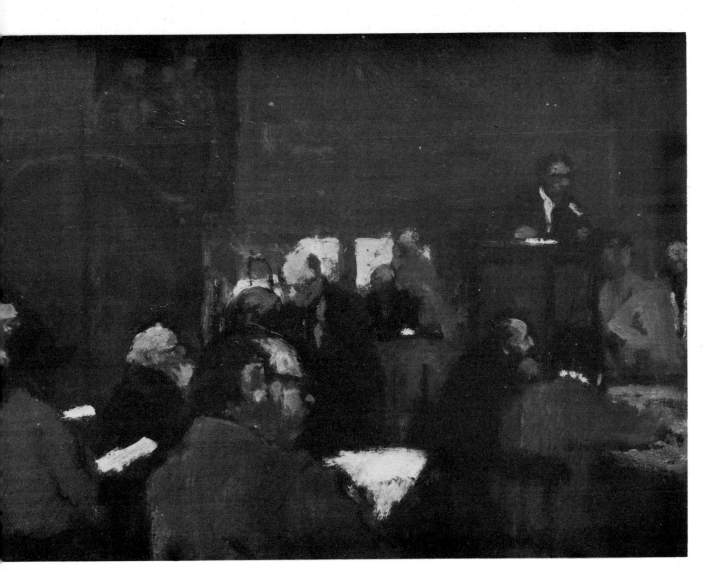

**Figure 103.** *Sotheby's* 12 × 9 in. approx.
To spend a morning drawing in an auction
room, such as Sotheby's, is as demanding
and absorbing a subject as any. The personnel
are constantly moving and changing, but
all are concentrating on the business in
hand, so that one composition after
another comes before the eyes. As many
people are writing in their catalogues the
draughtsman's activity hopefully goes
unnoticed.

and a large figure in the foreground, and the light inner room
framed by the doorway (Plate 18).

The Sotheby's paintings are quite different—which shows,
perhaps, how completely the form of the painting can be dictated
by the particular character of the place. Figure 103 is based on
studies made actually during an auction. The auctioneer at his
desk makes an obvious focal point for the composition, and
round him the audience and attendants group themselves in
constantly changing arrangements. The tonal contrasts are
particularly rich, with the dark clothes, light catalogues and
drawings, against a middle-toned green wall, something like the
cloth of a billiard table in quality. Figures 104–108 are some of the
drawings made in one session during an auction at Sotheby's.

Figure 109 is a much earlier Sotheby's picture, done, I suppose,
ten years or so ago. It is very typical of one's response to a com-
plex subject like this, in that the early version attempts to take in
the whole scene in a fairly centralized way. When one has gained
some experience in dealing with the subject matter, later versions
become more summary and selective.

**Figure 104.** Drawing done at Sotheby's—
a sketchbook page.
The colour in this scene is on the whole
sober—browns and greys in the audience,
and the mellow tone of old furniture. At
Sotheby's the walls are a particularly subtle
green, and the white accents of shirts,
catalogues and the mounts of drawings on
the wall show up brilliantly in the clear top
light.

**Figure 105.** Drawing done at Sotheby's—
a sketchbook page.

**Figure 106.** Drawing done at Sotheby's—
a sketchbook page.

PAINTINGS IN PROGRESS

**Figure 107.** Drawing done at Sotheby's—
a sketchbook page.

Art galleries are similar to auction rooms in some respects and form another variation on this theme of figures in interiors. About twelve years ago I became fascinated by this subject and produced a whole series of small pictures which attempted to capture the individual character of some of London's galleries—not only the National Gallery and the Tate, but dealers' galleries in Bond Street as well. One or two of these included miniature portraits of the gallery owners and staff.

**Figure 108.** Drawing done at Sotheby's—
a sketchbook page.

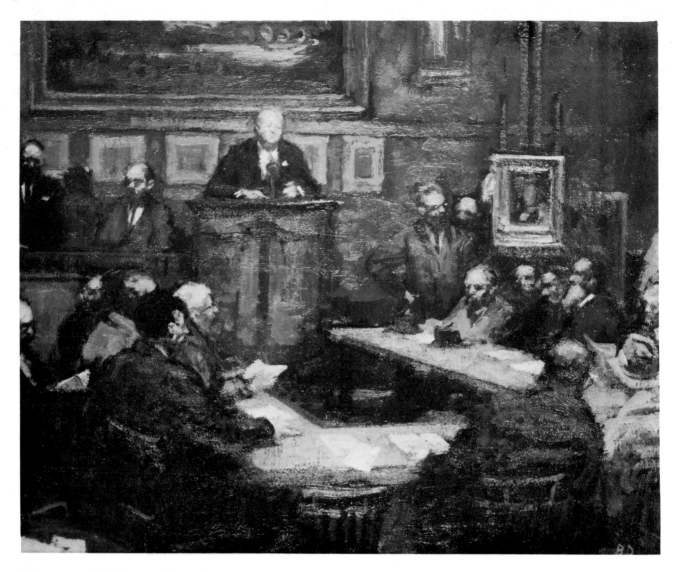

**Figure 109.** *Sotheby's:* an earlier version.
Canvas, 24 × 20 in. approx.

The R.W.S. Galleries in Conduit Street is one of the most attractive art galleries in London, and still retains its original style of decoration and its excellent daylight top-lighting. The white iron balcony rail makes a strong pattern along the top of the panel, and contrasts in its regularity with the irregular grouping of the figures. By comparing the painting with the drawing—hastily scribbled on the back of a circular with a ball-point pen—you can see that I have 'cut' the design at the top so as to concentrate it and remove the distracting, though attractive, presence of the figures at the top of the picture.

It may be worth pointing out that a picture like this one which uses a viewpoint looking sharply downwards, or upwards, may present problems in hanging. It should really be hung low down on the wall so that the spectator looks slightly down into it. Similarly, a picture showing an 'upwards' viewpoint—a low horizon, in other words—should be hung as high as possible.

PAINTINGS IN PROGRESS

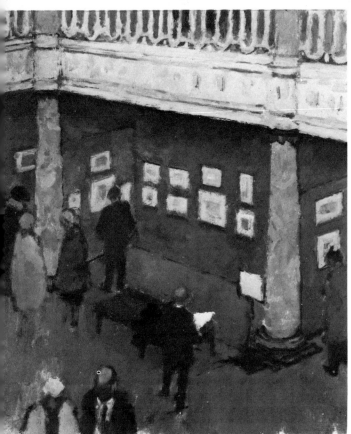

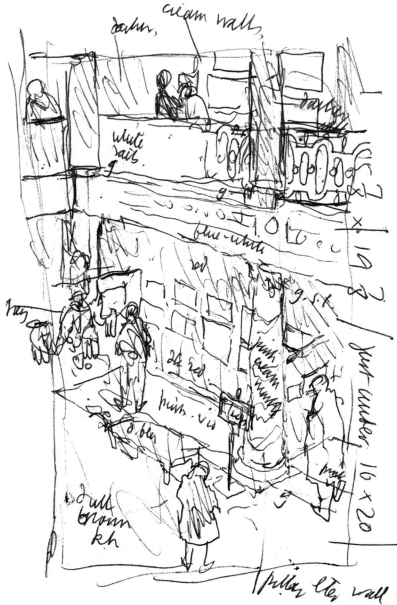

**Figure 110.** *RWS Galleries.*
This is one of the most attractive galleries in London, and still very much as it must have been 75 years ago. The drawings look particularly good on the rich red of the walls. Looking down on your subject like this presents new difficulties. This is the first picture I have done in this gallery, but I am sure that there are plenty of other possibilities here.

**Figure 111.** Drawing of RWS Galleries.
I was not prepared to do a drawing when I saw this attractive subject, so I had to use any materials which came to hand—the cover of an exhibition catalogue and a ball-point pen. Although not as sensitive a medium as pencil or as useful for indicating tone, a ball-point pen can be perfectly adequate.

# 11 'Frosty Dawn'

The original idea for this picture dates back to a winter stay at the cottage I have already referred to. It was very dark weather. Morning after morning was grey and gloomy. At last one morning the dawn broke with the sun rising through cloud, making a brilliant bar of gold above greyish-white frosty fields. It was not only a welcome change but also produced a dramatic and beautiful effect of light. The next morning was similar. This time, I made a hasty note in a sketchbook of the window, with that bar of sunlit cloud (Fig. 112). Later that day I began to think of ways in which it could be incorporated into a picture, and perhaps contrasted with an indoor light. Obviously it was necessary to use a figure in the room, and the pose, shown in its first conception in Fig. 113, seemed to happen quite naturally. Though I toyed with another idea, involving the action of kneeling and reaching up to turn on the light (Fig. 114), my original idea remained unchanged through a series of quick drawings made on subsequent mornings (Figs. 115–17).

That particular effect of the sunrise never happened again, so in a sense the picture is based on a memory of a momentary effect, backed up by notes, and subsequently built up into a composition.

It was possible to make careful studies of the figure later, as she was not much affected by the light from the window. More important, as far as the interior of the room was concerned, was the light from the lamp. I had decided at an early stage to have this bedside light on because of the resulting contrast between the very cold light through the window, and the warm, almost golden light which shone upon the pillows and sheets and, less obviously, modified the greys of the walls.

This mixture of light, contrasting indoor with outdoor quality, and having marked differences of warm and cool colour, has always attracted me. In fact, I am constantly surprised at the way many painters seem quite indifferent to complexities of lighting. Can this be due in part to the effect of so many teachers and

PAINTINGS IN PROGRESS

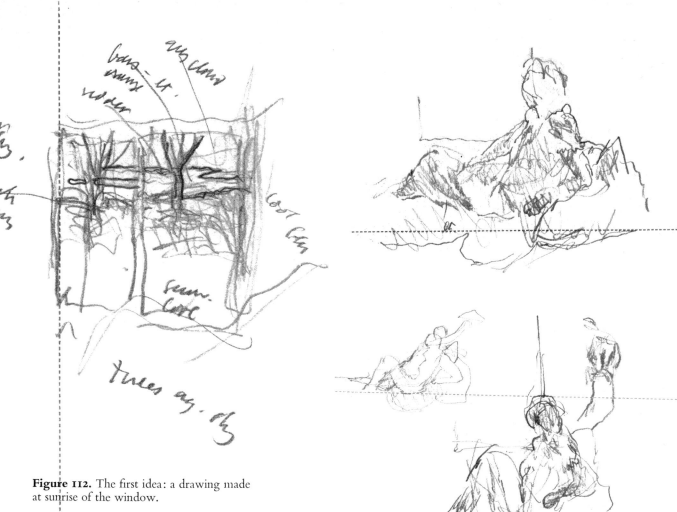

**Figure 112.** The first idea: a drawing made at sunrise of the window.

**Figure 113.** First ideas for the figure.

**Figure 114.** Alternative figure, leaning forward to switch on the light.

writers, who, since Roger Fry and post-Impressionism, have implanted the idea that it is somehow superficial, if not vulgar, to think too much about light? Structure and colour, yes, but not the influence of light. Yet without these different and constantly changing degrees and intensities of light, how dull a world it would be! I suppose this attitude among teachers of art developed partly in reaction to a certain flashy type of sub-Impressionist painting which relied for a great deal of its effect on back-lighting, highlights, and a general tendency to overdo 'effects'. I cannot stress too often that exaggeration and over-statement are traps which lie constantly in wait for the realistic painter, and particularly for one who is interested in light and colour. A master like Bonnard was able to use all kinds of lighting effects, including highlights and back-lighting, without ever lapsing into sentimental illustration, simply because of the superbly judged and very subtle relationships of colour and tone in his pictures.

As an example of what I mean by this sort of relationship, in this painting it would be fatally easy to overdo the contrast between warm indoor light and cold daylight. It is not a simple warm-cool contrast at all, in fact, because the brightest light in the sky is every bit as warm as the light in the room. The coldest

**Figure 115.** Studies of the figure.

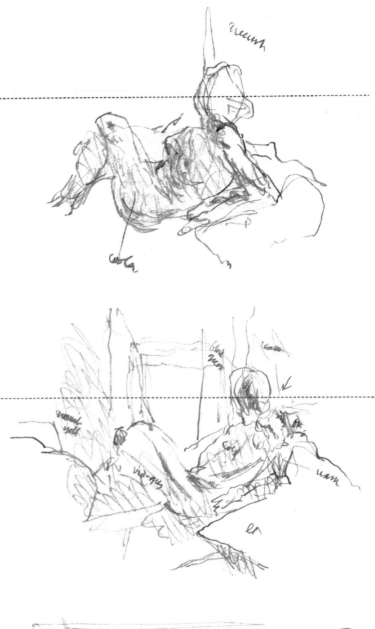

**Figure 116.** Studies of the figure.

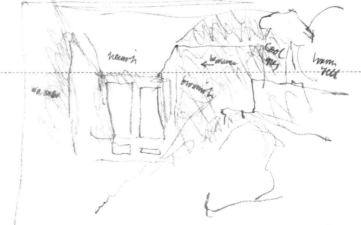

**Figure 117.** Note for the colours of the wall, etc.

parts in the whole design are the whitewashed window embrasures, which had a curious dead greenish-blue character. In comparison, the white wall in half-tone, slightly modified in colour by the lamplight, was a very subtle, almost brownish hue, changing to something colder and more definitely bluish round the lamp itself. Figure 117 shows some notes covering these important relationships.

The next stage seemed to be to make a small oil sketch to sum up what I had got so far. This is shown in (Plate 19). And, as a final stage in these preparations, because I wanted to get as much material together before returning to London, I made a fairly careful and informative working drawing (Fig. 118a and b).

The canvas size is 30 × 25 in., so it comes, for me, into the category of those 'middle' sizes that are sometimes so awkward. The first stage is shown in Fig. 119. You will see that I have kept quite a large area of space to the right of the figure. I didn't want her to be too dominant in size, or for her head to be exactly in the middle of the canvas. This first stage is still fairly monochromatic in colour, with the paint thinly scrubbed in.

Almost always I find that the increase in scale from small studies and drawings to the larger canvas brings its own problems. This is why I never feel it is any good for me to square up a small design for enlargement. I prefer to draw it out straight away on the full size, making what alterations seem to me intuitively right.

In this case I had some difficulties with the angular movements of arm and leg, which at first formed too self-contained a shape, making the figure too separate from her surroundings. In moving these parts of the design about, I began to experiment with altering the scale of the figure so as to bring her head nearer the middle of the picture. There is, of course, no reason at all why an important part of the design should not come on the half-way mark, although as it is obviously a dominant part of the picture area it does not need to be over-stressed. Many people may be a little afraid of using the middle of the canvas because of the danger, often quite imaginary, of the picture 'falling into two halves'. In this picture an important division between the wall and the window comes well away from the centre in the first stage (Fig. 119), but is later moved nearer the middle of the canvas. Although the whole tonal pattern of the picture is so un-centralized, this doesn't seem to me to be very important.

Working over the whole of the canvas quite freely I found that I was beginning to enlarge the lamp on the right into a more important shape, raising and enlarging the whole window area, and developing the shapes of pillows and sheets. At one stage I had the face and the wall behind almost the same tone and colour, giving a pleasantly under-stated result, but this was later lost when it became necessary to move the light window embrasure across so that it cut against the head (Plate 20).

At one point in this development the picture went into one of those periods of suspended animation—a fairly regular occurrence

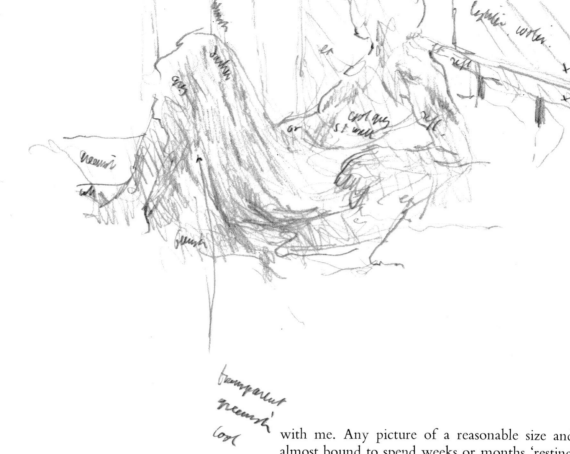

a little warmer

warmer grey

bluer grey

reflected window

cool grey 1st week

neumsi

transparent greenish cool

**Figures 118a and b.** Working drawings for the picture.

with me. Any picture of a reasonable size and complexity is almost bound to spend weeks or months 'resting' until the time becomes ripe for it to be taken out and re-examined. This does not only happen to large paintings. Sometimes quite small oil panels get re-worked years after they have been started.

In this case, as with the cottage picture described on p. 22, it was obviously necessary to take it back to the cottage and work on it again on the spot. When I was able to look at the picture once more in approximately the same lighting conditions, I was surprised at how dark it appeared. The colour, too, seemed far too cold and grey.

I find that if I lose interest in a picture it can almost invariably be revived simply be renewing contact with the subject. The same applies if I am stuck with some problem which has come up in the painting; a solution will invariably be found if the actual facts can be consulted again. If all else fails, I simply start painting from nature at any part of the picture which suggests itself. There are always plenty of things that are waiting to be worked on.

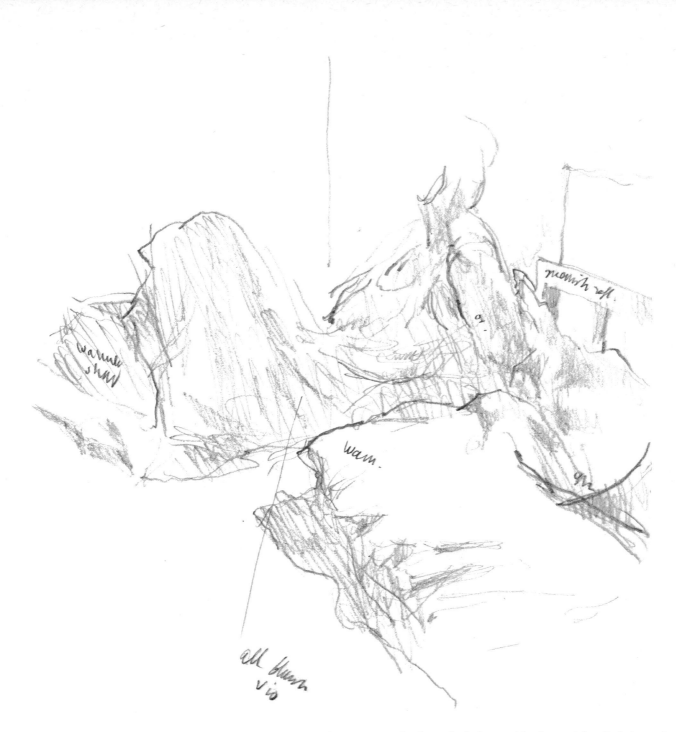

In this canvas I had to deal first with that tricky lighting. As the season of the year was different, every morning was far too light, unless I had started work at about 6.30 a.m., an hour which is a little too early for me. Eventually I was forced to the rather makeshift procedure of partially blocking up the windows by propping canvases against them, which cut off the daylight entering the room to approximately what I wanted. I found also that I had to put a low wattage bulb in the bedside lamp to prevent the electric light from swamping the cool, dim daylight.

When all this was set up, and the pillows arranged as far as possible as they had been before, I made another drawing, with plenty of notes, to help me get things clear in my mind, and then

'FROSTY DAWN'

got started with the repainting by putting on some touches of lighter and warmer colour in the wall behind the head.

In many ways it is rather a pleasant task to repaint a picture which has become too dark. The lighter touches you put on look very rich in contrast with the dull paint round them, and often comparatively little work will make a big difference. It is not so easy to lower the general tone of a picture which has become too light, for then the whole surface has to be worked over. This is most easily done by lowering the whole tone by means of a glaze—a transparent wash of thinned oil colour—which is allowed to dry and then painted into.

I found there was a good deal more variety in the colour, and spent a morning 'matching'. The slightly warmer, more pearly greys of the nightdress in shadow contrasted more, I found, with the bluish shadows on the bedclothes; the light on the sheets was on the whole creamier and warmer, and the wall had a greater variety of warm and cool greys.

This was as far as I went direct from the subject. I knew what I wanted to do next—to get the canvas home and put it up on the

**Figure 119.** First stage of the picture.

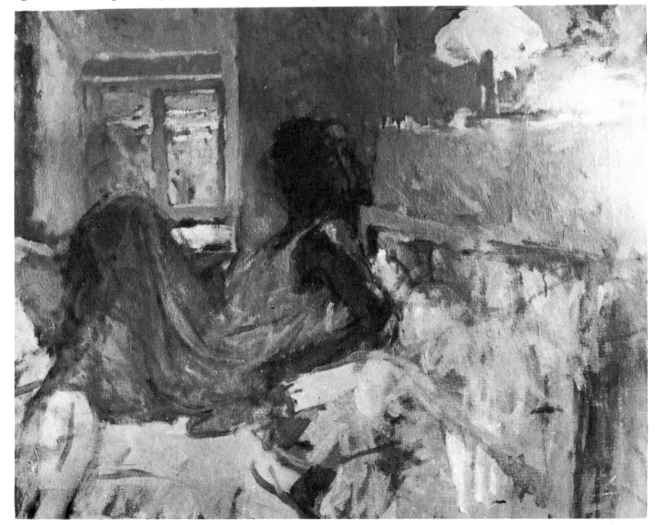

PAINTINGS IN PROGRESS

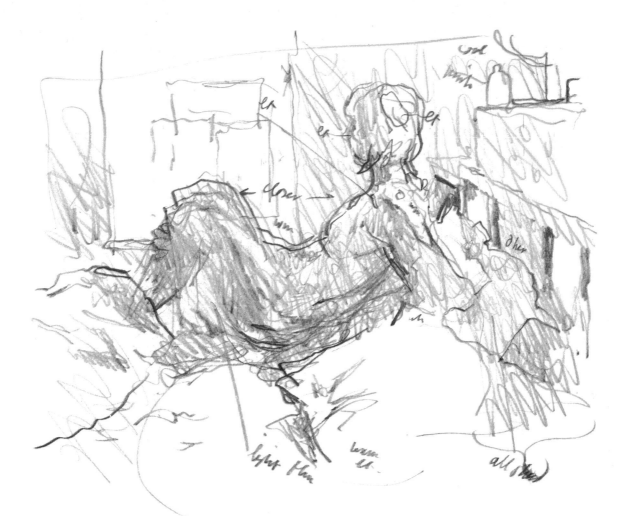

**Figure 120.** Another working drawing.

easel, to look at it in the mirror and even upside-down, and decide in what ways it needed pulling together. This process is always difficult to describe, but I find it usually entails deciding on the most important areas of light and colour, and reducing other areas in intensity, and also finding or re-finding important rhythms and connections, and stressing them.

Over a period of a month or two the canvas was brought out a number of times, and this process of final adjustment continued, resulting in a number of small changes. I became aware that over this period the picture was veering between a very realistic representation, which used the effects of light falling on the figure and the bedclothes, and a more 'designed', flatter and less realistic image. As time went on the picture began to settle down more definitely on the side of realistic light. I began to see that it was harking back more to the pictures I was doing fifteen years ago, and had more relationship with them than with my more recent compositions. This could be seen, for instance, in the painting of the nightdress. From a first stage in which the folds were fairly completely worked out, it became flatter, more simplified. Later on, the pattern of folds began to interest me again, and I found it impossible to resist developing them, and even the semi-transparency of the material, to a much greater degree. In its

'FROSTY DAWN'

turn this state had to be broadened again, until the compromise shown in the final stage was reached.

This pendulum-like swinging from realism to simplification is something which I find happens occasionally. I suppose to some extent it is the story of any picture's progress, for a compromise, or a balance, does have to be achieved at every stage between the demands of pure picture-making, that is to say the 'abstract' qualities of shape, tone and colour, and the 'descriptive' element which—for me at any rate—is inseparable from it.

The danger in this continuing process of adjustment was that the whole picture might become dull and 'go to sleep' on me. So I left it, without arriving at a definite decision as to whether the picture was finished for good and all, at the point you can see in Plate 20.

The main change in design has been that the window embrasure has now been moved across a little, so that the profile is silhouetted against it. The light edge of the face is, in fact, exactly the same in tone as this window embrasure. The face itself is another example of a balance, gradually arrived at, between description and the demands of the picture as a whole. At some stages it became much more specific, even illustrative, and then had to be brought back to a simple statement again.

One point occurs to me about all these alterations and similar changes in other pictures in this book, and that is the danger of what is underneath showing through the new paint after some time has elapsed. This is known as a *pentimento*, and there are a number of examples visible in pictures by the masters. The technical point to be grasped is a simple one. With time, oil paint becomes more translucent. Suppose that you painted a check pattern of black and white and covered it over, when dry, with such a thick layer of white paint that the check became quite invisible. After a certain number of years has passed, that check pattern would have become distinctly visible again. The same thing can happen, in a less dramatic way, with other repaintings. The moral is obvious. Where important changes have to be made involving the repainting of an area which has definite shapes or strong contrasts, the paint should be scraped down as completely as possible. This scraping-down process is in itself valuable because you can never know quite what effect it will have. All sorts of attractive and suggestive things can happen in the simple process of scraping with a palette-knife, such as blurred and cloudy forms, subtle surfaces and veils of graded colour, which can often spark off quite fresh ideas.

Other alterations, which are made into the wet paint during the course of work on the picture, do not need any preliminary scraping-down, unless, of course, the paint has become too thick to be easily worked into.

# 12 A figure composition

When I first started thinking about this book, I envisaged showing several ambitious pictures in different stages which would demonstrate quite drastic alterations and second thoughts, in contrast to the usual neat progression from start to finish. However, when it came to getting the photographic record while in the throes of painting the picture, it turned out to be not quite so easy; so that many of my illustrations are necessarily of finished pictures. In any case, many of my smaller pictures, I found, did progress reasonably smoothly from start to finish. For this chapter, though, I have been able to trace the development of a large picture a little more closely. The painting, in fact, is still unfinished, so it is quite genuinely a work in progress.

It is the sixth in a series of quite large and ambitious figure compositions based on the theme of bathers in the sand dunes. They have all been tackled in the traditional way of combining figures from separate studies into an imagined situation. It is fascinating to attempt a subject like this (though I have to admit that for many people it would seem a totally anachronistic way of working), because one is trying to do, however ineptly, the same thing that Poussin, Rubens and Titian were doing so magnificently all the time; for they invariably put their compositions together in this way in the studio.

Seurat and Renoir are two later masters of figure composition, and by their period we can see a change in the process of developing a figure composition—there are more preliminary sketches, and probably more alterations in the course of work. Nowadays we are likely to have a still more tentative approach, and are, so to speak, more inclined to let the picture dictate the changes it seems to demand as we work on it. This approach can lead to chaos unless the painter has a strong, overriding idea which he holds on to all the way through. Otherwise the design can be pushed around and altered *ad infinitum*, to say nothing about the colour. The 'plot' for such a picture, then—the theme which holds it all together—is very important. As long as it is a strong visual

**Figure 121.** Oil sketch of *Sunbather on Dunes* 8 × 11 in.
This is a small oil sketch painted on the spot, in one sitting. The tonal and colour contrasts, flesh against sand, are very subtle. Here they have been, if anything, understated, as I was interested in the way the colour changes very delicately from cream to violet-grey and pale ochre.

idea, it doesn't matter very much whether this theme is a story, such as in Titian's *Diana and Actaeon*, or a simple action; Renoir's great *Bathers* is developed entirely around the action of one girl splashing another.

Although the composition of the figure painting illustrated here is entirely imaginary, the situation is a familiar one to me. We have been going to these dunes for many years. At one end they are almost completely deserted, and it is quite possible, with one weather eye open, to paint or draw a nude there. All the pictures I have tried to compose on this subject have been pieced together from actual observations of a figure seen in sunlight against the sand and the varying contours of the dunes. Small oil studies painted on the spot, like Figs. 121 and 122, have been very important in trying to resolve the extremely subtle colour relationships of figure and sand.

My 'plot', or theme, for this large picture was largely made up of formal ideas. I wanted to use the slope of the dunes to place figures at slightly different heights, and I intended the colour to be in a very light key, with little or no modelling or heavy shadow, and big, openly lit, rather flat forms. I also wanted the group to be linked by strong rhythmic directions.

On a warm, pleasant day in July I made a series of drawings in a sketchbook (Figs. 123 and 124). These were restricted to about three ideas—a figure lying back with legs crossed, and two figures

**Figure 122.** Oil sketch of Sunbather:
$8\frac{1}{2} \times 11$ in.

**Figure 123.** Figure drawings made in the
dunes.

131

A FIGURE COMPOSITION

**Figure 124.** Figure drawings made in the dunes,

**Figure 125.** Study of sand dunes.
This drawing concentrated on the rhythmic movement and sweep of the dunes, and the way the tufts of grass and their shadows build up into light and dark shapes. In the foreground, in shadow, is a pile of clothes and shoes. The whole drawing is merely a note for future reference, scribbled down with notations of colour.

PAINTINGS IN PROGRESS

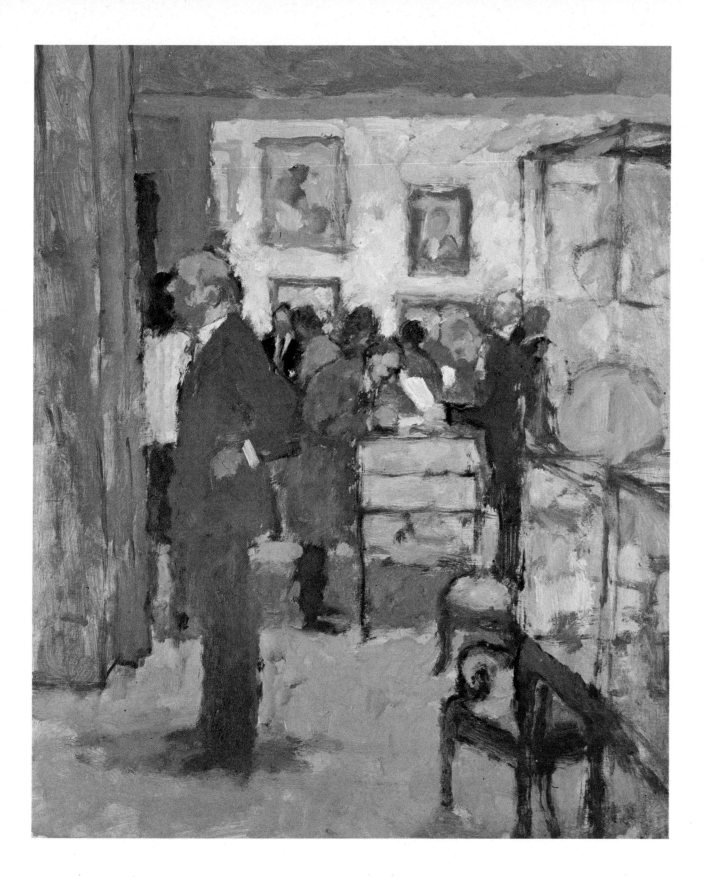

**Plate 18.** *Viewing at Christie's* 12 × 9½ in.

**Plate 19.** (Left) Oil sketch. Oil on panel $9\frac{1}{2} \times 11$ in. A small oil sketch, done as a preliminary study, is probably most satisfactory when it concentrates on saying just one thing—in this case, the way the light behaves. The pale honey-coloured ground is almost untouched on the right-hand side of the picture, where it is allowed to stand for the lamp-lit area. The colour of the nightdress and bedclothes is quite carefully noted down, but their exact shape and structure is left to be worked out later in drawings.

**Plate 20.** (Below) *Frosty Dawn*. Final stage of the picture. Oil on canvas $25 \times 31$ in. This is the final stage of the picture. Though some vigour and immediacy is necessarily lost in the large canvas, worked over and reconsidered as it is, one always hopes that it will contain more complete statements and greater complexities of design. Sketches are almost always 'livelier', because they concentrate on one or two things and leave the rest understated. (Collection of Mrs J. T. Burns.)

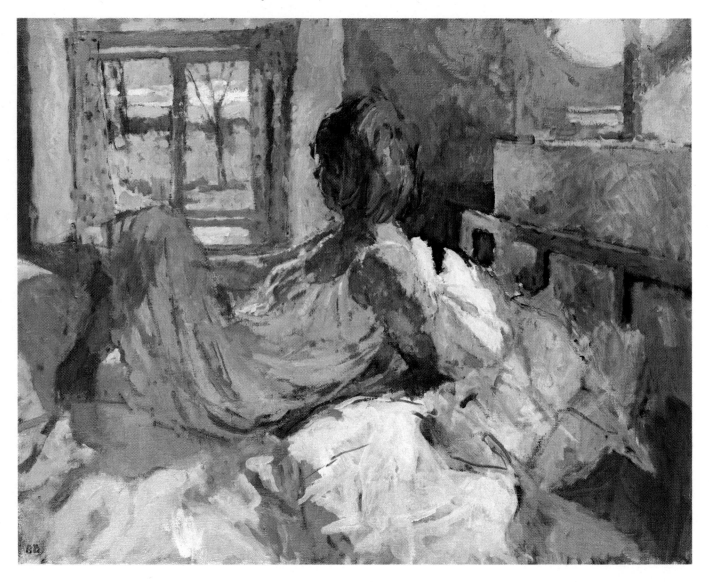

**Plate 21.** Oil sketch for composition 8 × 11 in. This is a small oil study done in the studio to help me make up my mind about the composition. There are so many possibilities in a figure group of this kind; one could go on *ad infinitum* moving the figures about in drawings, and so a slightly more complete sketch like this can be a great help. The change of medium, and the introduction of colour, helps one to see it as a picture.

**Plate 22.** Third stage of *Bathers on Dunes*.

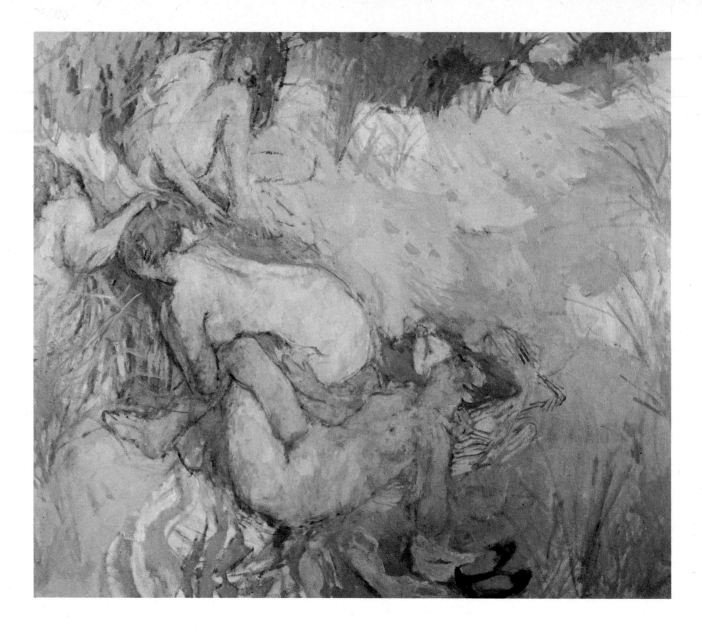

**Plate 23.** *Bathers on Dunes*. Latest state of composition. 42 × 47 in.

**Figure 126.** Composition drawing for
*Bathers on Dunes.*

kneeling or crouching. I hoped to build up my design largely out
of these three ideas. I also made studies of the actual shape of the
dunes, which formed a sort of valley or hollow (Fig. 125).

I had already decided to use a flat lighting, and I noticed again
on this sunny day the way that the colour of the light sand—not
at all a yellow colour—made a foil for the glowing bright notes
made by clothes, towels, and so on. A number of small exploratory
drawings and scribbles of the whole group followed (Fig. 126),
together with a small oil sketch (Plate 21). While I was working
on these I was preparing the big canvas so that it would be ready
to start on as soon as possible.

The three nude figures in the sketch are identical to the ones in
my drawings. The fourth, who has come into the picture at the
left and is doing up the hair of the kneeling girl, is purely an
afterthought; she seemed necessary to continue the running
rhythm across the line of figures. This group would otherwise
have been too enclosed, too self-sufficient, as you can see by
covering up the new figure. Working out a line or 'chain' of
inter-connecting movements is, to me, one of the greatest
satisfactions of figure composition. Here the juxtaposition of the

**Figure 127.** First stage of *Bathers on Dunes*.

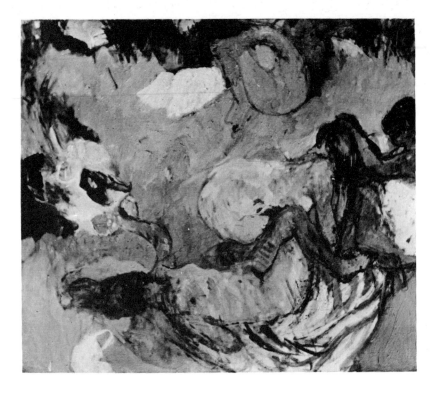

two nudes gave me a rather complex angular 'knot' where the legs of the one lying back meet the arms of the girl leaning forward. This is connected by the bent legs of the extreme left-hand figure into a series of angles, rhythmically linked. The three figures make a sort of chain, looping up towards the left side of the picture. This main formal motif is emphasized by the colour. The observed fact that in summer the arms, heads and legs tend to get more sunburnt than the rest of the body has been used to strengthen the pattern in those parts where the main articulations occur.

I could see that the isolated figure at the top of the picture was not satisfactory, and I knew that I would eventually have to do something about her, but I felt I now had enough settled to justify getting to grips with the big canvas. I don't like putting off this moment too long, largely because I know that the bigger scale will inevitably force me to re-consider the composition to some extent.

Figure 127 shows the canvas after two or three sittings. In the first loosely sketched drawing some alterations have already been made; the relative angles of the nude figures have been changed, and the left hand figure has come down lower. That figure at the top was obviously going to be the difficult one; I find that almost every picture on this scale has at least one awkward bit, which has to be repainted over and over again, and also some part which stays unaltered from first to last.

Figure 128 is of a stage a day or two later. Apart from a general working over the canvas, and a tightening up of the drawing, the main change is the placing of the figure at the top. I felt she formed too heavy and enclosing a shape, and tried the effect of

**Figure 128.** Second stage of *Bathers on Dunes.*

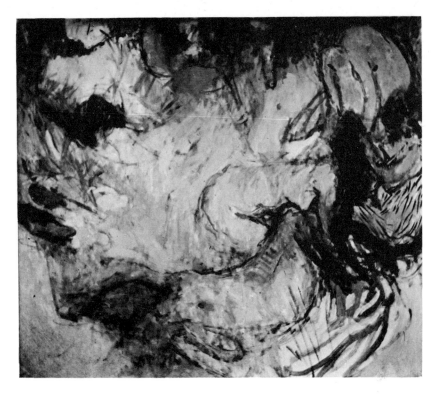

leaving a space between her and the others. However, she soon returned. I believe that novelists and playwrights sometimes find that a character will begin developing, as they write, along lines they have never intended. Certainly the same kind of thing can happen in a painting. This is what I mean by saying that in some respects the painting can seem to dictate what the next step should be, without the painter's conscious volition. The pile of clothes on the right was also developed at this stage.

Now followed a break of about six weeks. The first impetus of the painting had exhausted itself, and it was put away against the studio wall. I find this is quite usual when I am engaged in anything at all ambitious. At intervals I will pull the canvas out and have a look at it, and eventually the time seems ripe to get to work again. When it came back on the easel, some time in October, after a trip abroad and a spell of working only on small pictures, it was ready for a general shaking-up. The near figure was changed slightly in scale, and the pile of clothes first came down lower and then vanished entirely, as it seemed too obviously to balance the 'knot' of arms on the left. The crouching girl at the top has settled down into her place. The main difficulty in this session of work was the figure on the left, doing up the nude bather's hair. Previously there had seemed nowhere for her legs to go, and she was either awkwardly cramped, or too obviously echoing the line of another figure. I eventually decided to turn and twist her a little so that her back is showing. Her forearm continues to run roughly parallel to the leg of the nearest bather, and now makes a right-angle with the arm above it. Her dress has become a cool violet (Plate 22).

This stage, shown in the second colour plate, seemed to be

**Figure 129.** Drawing for composition.

approaching a sort of completion; the design was settling down, and I assumed that quite large areas of the canvas would hardly need touching again. There were some unresolved areas, however. The dunes themselves had by now been considerably re-worked, the diagonal direction of the shadow on the sand being changed to a more curving shape, but I felt that there was still a good deal to do in order to make the valley-like structure clearer. I have been painting these dunes for years, but it never gets any easier to manage the clumps of grass, with their tantalizing combination of soft mass and delicate springing line. All that area at the top, which has not had much done to it since the early stages of the picture, and the grasses in the foreground, still needed working on.

I mentioned before that there are parts in a big picture which give continual difficulty, and others which seem to stay untouched for long periods. The latter is represented here, or so I thought, by the striped towel in the left foreground, as you can see by comparing the different stages up to now.

However, it didn't stay untouched for long, for after another rest the canvas was subjected again to a drastic upheaval. The stage which seemed before to be approaching completion now appeared very unsatisfactory to me. I had been uneasy before, but now I felt strongly the need to break up the forms, to get things moving again. After the last interval, the picture seemed to have become stale and stodgy.

The canvas went up on the wall, held by a few nails (I often work in this way, rather than on the easel), and I began to lose the edges throughout the figures, reducing the design as far as possible to areas of colour and getting the drawing moving again. A small composition drawing made during this process (Fig. 129) clarified various ideas about the figures, emphasizing their movement somewhat; the uppermost figure has now almost dissolved away. On the other hand, the distinction between the light and shadow on the dunes has been considerably strengthened.

To 'lose' the edges in this way, to make the form less linear, is an almost instinctive reaction to the feeling that the painting has become stuck, lacking life and movement. I should emphasize that such blurring of contours is only an intermediate stage to make re-drawing easier and, even more important, to suggest possibilities which one had not seen before. When a painter works across a form in a complicated design like this, he is opening up innumerable possibilities. A blurred form in juxtaposition to others may suggest an alteration in pose or movement which would be unlikely to come about by other means.

In the final two or three days of work at the picture a good deal of re-drawing was done, much of it to the uppermost figure, which has emerged again. The line of her leg and thigh turned out to be essential, making directions which link with the other diagonal movements in taking the rhythms up to the top of the canvas (Plate 23).

I do not consider this stage to be necessarily the final one. In one sense, indeed, this kind of picture is never finished and a certain amount of dissatisfaction is almost inevitable. This could mean that after some time it will find its way again to my easel, to receive either small adjustments or major and radical reworking.

# Conclusion

Once again, I must stress that the approaches to painting described in this book are merely those which I have developed as suitable to my own work. I have tried to describe from the painter's point of view—from the inside, so to speak—the way that certain pictures have come about. I am certainly not putting forward any particular method as one which I would like other painters to adapt; indeed I have not thought of myself as giving specific advice at all, or of writing a 'how to do it' book. I would, of course, be glad if something in these chapters is found of some use to other painters or students; but I am inclined to think that if anything is useful it will be general principles and ways of thinking, rather than specific 'ways of painting'. These are purely personal. I am sure that every individual has to develop, on his own, the methods that will suit his own temperament and vision and go through a process of finding things out for himself; for the effect of the melting-pot of the last hundred years is such that every painter is now free to select and develop any style he pleases. The danger of this is simply that it can lead to too great an emphasis on style. It is better, in my opinion to forget, as far as possible, all about styles and manners, and to try simply to paint as one's own temperament and interests dictate.

It is possible to classify artists' temperaments in all sorts of ways, but at the risk of making an over-simple generalization I am tempted to say that one of the main differences is between those painters who naturally like a free or 'painterly' quality, and those whose natural tendency is towards precise drawing and detail.

The former category includes all those painters who to some degree are the heirs of Impressionism. Their work is, in general, based on working from nature; effects of light and colour are important to them, and they relish the sensuous aspects of the medium of paint.

Although I belong to this category myself, I have the greatest admiration for the opposite kind: the 'tight' painters. One of the most fascinating artists, to me, is Ingres, and I think anyone

would have to admit that the greater part of the world's master-pieces have something of this quality of precise handling. A walk round the National Gallery should prove this point. Apart from this, though, it is simply true to say that many people have a natural liking for firmly controlled outlines and precise detail. I would go further and say that this is the natural and healthy way for anyone beginning to paint, however he may develop later.

If you are a naturally precise painter it is surely a waste of time to think that you ought to be able to 'paint freely'. A teacher who implants this idea, as I think many have done, is a very bad teacher. I have often been told by amateur painters that they wish they could 'loosen up'; it always strikes me as a surprising ambition, and not anything that could be attained for its own sake. A free, loose touch comes about, if at all, in the attempt to attain other qualities, such as the envelopment of the forms in light, or the analysis of minute colour changes; far from being the opposite of a precise touch, in fact, it develops out of the attempt at other sorts of precision. It must be a by-product, not an end in itself.

This is one of the reasons why I don't want this book to be taken as specific advice. My own methods have developed slowly; I painted very differently when I first began. They suit me now, but I would not necessarily recommend them to others. However, I hope that some of the ideas and approaches may be of some help even to those whose natural bent is quite different. It is the attitudes that count, after all, and not this or that way of putting on the paint. The best advice that can be given to any painter is simply this: if you like doing it, then go ahead and never be put off by someone trying to make you feel that it is mistaken or out of date. I say 'like *doing* it' intentionally, because I believe that the intense pleasure and sense of discovery that one gets from the actual process of painting is what matters. It is possible, after all, to want a particular result, but to take little or no pleasure in the carrying out. This would apply to one of those dreary exercises involving the laborious copying of a photograph, for instance. The result may be superficially impressive, but I cannot think that anyone can get anything of value from it, or even enjoy doing it very much, and this fact makes the finished result of little real interest or value.

Looking back over these chapters, I see that my emphasis has been placed so much on individual pictures and their progress that I have not been able to deal in any depth with general subjects, such as composition or colour. I think that I have, in fact, reflected fairly accurately what has consciously gone on in my mind in the course of doing a picture, but this cannot take into account the almost unconscious below-the-surface store of experience and knowledge that any painter accumulates about such matters—the result of years of painting, looking at paintings, and thinking about painting. I will try to put down some notes about these aspects of picture-making, in an attempt to bring some of this subconscious background forward into the light. This means

talking a little about beginnings.

When I was a student colour was hardly mentioned, and I cannot remember anyone saying anything very illuminating about composition. Drawing was the subject which received the most concentrated teaching, and painting tended to be taught rather as if it were an offshoot of drawing in the life class. In other words, great attention was placed on working from the model with close observation of tonal relationships and modelling, while colour was kept comparatively limited and subdued. It is amusing to see how different aspects of the craft of painting receive emphasis at different periods in art schools. At a later stage—I was by then teaching myself—I remember far more emphasis being put on composition and its geometrical basis, and for a time 'golden sections' were on every teacher's lips and apparent in every student's painting. Later again, 'colour studies' came in, but of this more later.

When I say that no-one among our teachers mentioned anything that I can remember about composing a picture, I am not exaggerating, although this is very likely the result of my own lack of attention as a student. It was quite usual in those days to devote one day a week to composition, as a separate subject from life drawing and painting; composition never seemed to be referred to in the context of painting from the model. Whether we suffered from this lack of connected teaching is debatable. It probably slowed down our development, though sometimes in pessimistic moments I am inclined to think that both colour and composition are unteachable anyway, and that we were lucky not to fall into the hands of brain-washing theorists. Still, much as I believe in finding out things for oneself, I have to admit that a little sympathetic direction at the right moment can open one's eyes. (As Constable said, the self-taught artist has studied under a very bad teacher.) I am very glad that later I got to know artists who put great emphasis on the logical structure of the picture. This linked up with a very early interest of mine in abstract painting of the constructivist, geometrical sort. I had a passion for this while still at school, and some of my earliest paintings were attempts in this idiom. It was quickly replaced by other interests and almost forgotten, but years later this interest in geometrical structure was revived in the form of the compositional 'bones' of figurative painting. There are many books on the subject and I do not intend to go into it here, but I am sure it was a very useful discipline. I do not consciously use geometrical devices in working out a picture any more, but it is all there subconsciously.

It is certainly not necessary to go very deeply into geometry; in fact it may prove a distraction to get too immersed. To give a picture a satisfying unity and stability it often suffices to be aware of the relationship of squares and right-angles within the rectangle; to add to its sense of rhythm and movement it helps to think of the linking or opposing linear directions—the way things "rhyme"—a sweep of hillside checked by an opposing movement,

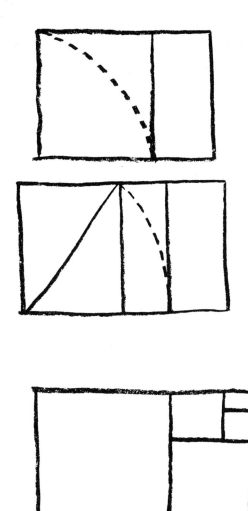

**Figure 130.**

or a bent limb forming a tilted right-angle which relates to another in the opposite direction. All these movements set up within the picture area must be seen in relation to the actual outside rectangle of the canvas.

It will often be found, I think, that a figure placed in the rectangle without conscious formal planning, but with some care and consideration, will turn out to fit snugly into a geometrical division. Such a division may be a square formed by dropping the shorter side of the rectangle on to the longer, for instance, or the division formed by bisecting the rectangle, making a diagonal of one half, dropping it on to the longer side and raising a perpendicular (Fig. 130). These are classical ways of establishing a secure and satisfying main division of the picture, used by countless artists of the past. Examples who come to mind are Poussin, Raphael, Piero della Francesca and Seurat.

To become a little aware of geometry also helps one to be more conscious of the basic shape of the picture and the different characteristics of the various proportions, from squares to long thin rectangles. Of course, there is no guarantee that a picture will be any better merely because there is some geometry in its construction. A dull or insensitive picture is still dull, even if it is as full of golden sections as a cake is with currants. But I have no doubt that it can help a good picture, giving it firmness and point, and adding an additional layer or undertone to its existing layers of meaning—a sort of counterpoint.

Apart from geometry and the division of the picture space, there are a number of compositional features that I have become more conscious of over the years, through that gradual process which goes on throughout a painter's life—for he doesn't, or shouldn't, stop finding out new things merely because he is no longer a student. Being married to a fabric designer (now a painter as well) has made me more aware of the linking movements which run from one part of a composition to another, for the designer has to be very much aware of these. In the end, perhaps the most important thing about composition for me is the fact that it must grow out of the painter's response to his subject, rather than be imposed upon it. A good composition can develop from some 'germ' in the subject which the painter hadn't even been aware of when he started. He begins a drawing or a painting simply because he is attracted by something he sees which he can't resist. In studying it he begins to find that some part of the subject relates, perhaps, to something in the background which was almost unnoticed before; this relationship may even take over and become a major stimulus in the final picture. Or in a subsequent sitting someting may have altered—and it is remarkable how to the painter struggling with his picture almost any alteration can seem to be an improvement—which brings some other relationship into unexpected prominence.

One's ideas about composition, then, have to be very flexible and one must be ready to accept possible changes. I feel the same could be said about colour, though I have to admit that there

are also perfectly successful pictures which start off from a formal or abstract idea hardly dictated at all by the subject—such as deciding to paint a circular picture, or a blue and pink one.

Colour must be the most subjective and subtle of all the aspects of the painter's art, and the one which has had the greatest number of attempts, from Goethe onwards, to systematize it. There have been innumerable teachers and theoreticians who have made up colour scales, circles and charts which should, according to them, result in 'perfect' harmonies, but I have always doubted whether theoretical study can do much for a painter's sense of colour, and I have a great sympathy for the Flemish painter who, on finding one of his pupils studying a treatise on colour harmony, advised him to 'put it away and rather to spend some time on observing what is to be learned in the way of harmony of colours from the sky at sunrise and sunset—but then it would be a question of seeing with heart and soul'.

To me, this gets at the heart of the matter in two ways. First, good colour is so much a question of subtlety of graduation, the relation between neutrals and purer tones, the play between warm and cool. All of these can be observed in the sky, or, for that matter, in the painting of flesh; none are adequately covered by the theoretical approach, which almost invariably deals with flat areas of pure colour.

Secondly, the Flemish painter's insistence on 'seeing with heart and soul' seems to me of paramount importance. What we learn as painters through an emotional attachment to the subject is more likely to be of use to us than merely abstract knowledge.

The actual material quality of the colour also gets left out from the scientific approach, and this always seems to me very important. All the finest colourists also have a sensitive feeling for the quality of surface that they are making, and a picture in which the painter has enjoyed the 'feel' of the paint has a better chance of achieving good colour.

Again, I am grateful to my own training for insisting on the accurate observation of tonal changes, even if colour was not often mentioned, because this seems to me an excellent preparation for examining with equal attention later on the gradual changes of colour, for example as the light falls across a form. One essential fact about colour was, indeed, stressed; the changes from cool to warm colour in the painting of a head. It could almost be said that if the student can make a good shot at this very subtle problem he is well on the way to becoming a colourist.

It is perhaps a comforting thought that most of the finest colourists have begun by painting low-keyed, sometimes almost monochromatic pictures—a study of the history of art will give plenty of examples, so I need only mention Van Gogh and Manet. Certainly a sensitive handling of neutrals and greys is an essential part of the painter's development and it has often been said that it is in the use of half-tones that the good colourist can be seen.

I hope I have shown that painting is a continuously developing process and that one must be learning all the time. Most painters

know the feeling, which comes over them from time to time, that they are painting as incompetently as if they had forgotten everything they knew. This can happen to one when faced with a different climate, or an unfamiliar light. Though a disturbing experience, it is actually a good sign, I believe, and shows that one has not merely become stuck with a formula.

As one gains in experience one can, indeed, actually grow less good at doing certain things. For instance, I used to be able to paint small heads or figures very quickly and directly, a thing I find increasingly difficult now. This sort of change is not, one hopes, merely a sign of growing incompetence or senility, but occurs because one is looking for different and more subtle things, and is less satisfied with an easy result.

Painting is unlike other crafts in that one doesn't simply get better at it; rather one hopes with increased experience to retain, or indeed to get back to, a kind of naïvety. This freshness of vision is actually not often seen in young painters' work. Matisse, in fact, said that it had taken him fifty years to see with a child's eye, and Bonnard is perhaps the greatest example of a painter who saw more freshly as he grew older. My own hope for the future would be not only increasing skill or range, but also just this ability to see more clearly the oddities and strangeness in our everyday visual experience, and to go on finding fresh delights in unchanging subject matter.

# Books
# and materials

In a book which makes no pretence at being either scholarly or instructional, a bibliography is hardly strictly necessary; neither is a list of suppliers of materials. However it might be of interest to add some purely personal suggestions. Here are a few books which have meant a great deal to me in my development as a painter, and which have become indispensable companions. Not all of them are easily obtainable today, but I list them nevertheless in the hope that others, if they can come across them, may find them stimulating.

I have put them roughly in alphabetical order of subject.

*Bonnard and his Environment:* Museum of Modern Art N.Y. 1964
*Bonnard:* Annette Vaillant. Thames & Hudson, London 1966
*Cézanne:* Jack Lindsay
*Cézanne;* letters: ed. John Rewald
*Constable, the Natural Painter:* Graham Reynolds. Evelyn, Adams & Mackay, London 1965
*Memoirs of the Life of Constable:* G. R. Leslie. Phaidon, London 1951
*Degas à la Recherche de sa Technique:* Rouart. Floury, Paris 1945
*My Friend Degas:* Halévy
*The History of Impressionism:* John Rewald. Museum of Modern Art N.Y. 1961
*Landscape into Art:* Kenneth Clark
*The Nude:* Kenneth Clark
*Picture Making Technique and Inspiration:* Charles Sims. New Art Library, London 1934
*Camille Pissarro: Letters:* ed. John Rewald. Kegan Paul, London 1943
*Renoir my Father:* Jean Renoir. Collins, London 1962
*Modern Painters:* John Ruskin
*Elements of Drawing:* John Ruskin
*Seurat:* John Russell. Thames & Hudson, London 1965
*Sickert:* Wendy Baron. Phaidon, London 1973

*Sickert:* ed. Osbert Sitwell: A Free House! The Artist as Craftsman. Macmillan, London 1947

*Turner, a critical Biography:* Jack Lindsay. Panther books, London 1947

*Life of Turner:* A. J. Finberg

*Whistler:* Denys Sutton. Phaidon, London 1966

*Vuillard:* Museum of Modern Art, N.Y. 1954

*Vuillard:* John Russell. Thames & Hudson, London 1971

As for artists' materials and their suppliers, I thought that instead of the kind of list which is usually found in books dealing with techniques, it might be useful in the present economic situation to substitute a few remarks which could help any painter to save a little money on his purchases of materials. It does not harm to do as many things as possible ourselves, rather than pay someone to do them for us, even if this entails a certain amount of improvisation and takes some time.

Unfortunately there is not much the painter can do in the way of making his own business; and in any case this is one instance where we can say that only the best is good enough. Grinding your own colours, too, is a laborious procedure, and will not turn out to be much of an economy measure. Where it may well be useful to the artist is in teaching him something about the very different 'feel' of oil paint as used by the masters of the 17th, 18th and early 19th centuries, before machine production got under way.

Powder colours—pure pigment, that is—which can be used for grinding up oil paint at home, or used with any other media such as egg-tempera or distemper, may be obtained from **Cornelissen's,** 22 Great Queen St., London W.C.2. The same suppliers will provide rabbit-skin glue of high quality which can be used for sizing canvas and panels. It is sold either in sheet form or the more convenient powder.

Two other suppliers whose names should be mentioned here are **Brodie and Middleton,** 79 Long Acre, London WC2, who have a good range of comparatively inexpensive colours and other materials which are used a good deal by scene painters and decorators, as well as by artists; and **E. Ploton (Sundries) Ltd.,** 273 Archway Rd., London N6, who carry a large stock of imported (mostly French) colours and supplies, as well as many out-of-the-way materials.

Raw, unprimed canvas is sold in several grades by **Russell and Chapple,** 23 Monmouth St., WC2. A great saving may be made by preparing canvases oneself, not to mention the advantages of being able to make the priming just as one wants it. I have described a simple egg-oil emulsion primer earlier in this book.

Any timber merchant will be able to supply hardboard, still the most satisfactory material for panels. At the larger yards, too, can be found timber mouldings of various kinds which can be combined and adapted to make perfectly adequate frames.

While on the subject of wood, it is possible for anyone with a

rudimentary knowledge of carpentry to construct a solid studio easel based on the traditional pattern, though minus certain refinements. Such an easel is almost unobtainable commercially nowadays, and second-hand examples fetch a steep price.

Stretchers for canvases, however, do require very skilled carpentry, as the mortice and tenon joints must be extremely accurate. It is better to buy them from a specialist firm who will make up stretchers of any size to order: **Bird and Davies,** 52 Rochester Place, London NW1.

It is always worth while to buy the various liquids—turps, linseed oil, and white spirit—in quantity. The tiny bottles sold by artists' suppliers are a quite unnecessary extravagance. I buy my turps in 5-gallon drums from **Hunter–Penrose–Littlejohn Ltd.,** 7 Spa Road, London S.E.16. I have never used anything except the ordinary raw linseed oil. It is yellow compared with the far more expensive refined variety, but in practice this seems to make no perceptible difference.

Finally, paper and sketchbooks. Really good quality paper is already becoming scarce and expensive, and will certainly get more so. Perhaps we should start hoarding now. I have found it useful to keep a folder into which I put any scrap of attractive paper, from wrapping paper to the finest hand-made variety, which comes my way, sometimes even going to the lengths of cutting fly-leaves out of catalogues. If you buy paper in quantity it is not only cheaper, but you can make up your own sketchbooks. Bookbinding on this simple level is quite a pleasant and rewarding activity. The paper need not, of course, be expensive; I have used a box of ordinary typing paper—the thicker variety—to make up a number of small pocket-sized notebooks at a minimal cost; the paper is excellent for drawing in pen or pencil.

Most of these suggestions, I realise, demand a certain amount of time. But this can easily be exaggerated; an evening spent here and there in preparing canvases, for instance, will not really mean a great deal of time lost to one's work.

# Index

drawings, painting from, 23, 24, 51, 73, 87
dress, 72

easel, 15
edges, 24, 43, 141
emulsion, 16

figure drawing, 87
figurative painting, 11
flat pattern, 102, 127
Fragonard, 42

Gauguin, 65
gesso, 17
geometry, 144
Gilman, 91
glazes, 32, 126
Goethe, 146
Goya, 11
greys, 24, 146

handling, 45
hardboard, 16

Impressionism, 142
improvisation, 12, 70
Ingres, 84, 87, 142

John, Augustus, 87

life drawing, 22, 87, 89
light, 34, 41, 102, 111, 120, 125
light, electric, 14, 23, 69
lighting, studio, 14, 46, 125
likeness, 11, 33

Manet, 146
Matisse, 147
medium, 15
memoranda, 22, 85, 112
memory, 11, 52
Millet, 90
mirror, 14, 46
models, 21, 47
movement, 78
musical instruments, 78, 83

nature, painting from, 124
nudes, 40, 46

oil studies, 20, 130

outlines, 43, 143
over-statement, 60

paint box, 18
panels, 16
pencil, 92
*pentimento*, 128
photographs of paintings, 39
Picasso, 12, 84
Piero della Francesca, 145
placing, 30
pochade, 18
pochade box, 18
pose, 21, 29, 34, 35, 40, 44, 120
Poussin, 117, 145
priming, 16

quartets, 79

Raphael, 87, 145
rehearsals, 73
Rembrandt, 11, 40, 90, 92
Renoir, 22, 40, 129
repainting, 31, 82, 126, 128
Reynolds, 9
rhythms, 30, 127, 144
Rubens, 9

San Gimignano, 67
scale, 10, 32, 66, 95, 138
scraping down, 82, 128
series, 10, 22, 50
Seurat, 129, 145
Sickert, 50, 55, 90
Siena, 50, 51, 53
size, 16, 17
sketchbook, 52, 92, 130
Spencer, Stanley, 13
studio, 13
subject matter, 10
surface, 146

thumb-box, 19
Titian, 129
tonal pattern, 70, 123
tone, 43, 126, 146
tone, notation of, 81, 91
toned ground, 17, 81
touches, 44
triptych, 109
Turner, 52, 92